Marketplace:	HalfDotCom
Order Number:	6058039
Ship Method:	Standard
Customer Name:	Albert Ku Lin
Order Date:	1/14/2016 5:07:01 AM
Marketplace Order #:	10501881441O1
Email:	albertlin@rocketmail.com

Items:

Qty Title	Locator
1 Our Beautiful, Fragile World: ...	LO1-1-11-017-001-3418

last-page-books-Columbus
3860 La Reunion Pkwy
Dallas, TX 75212
outletohio@hpb.com

Our Beautiful, Fragile World

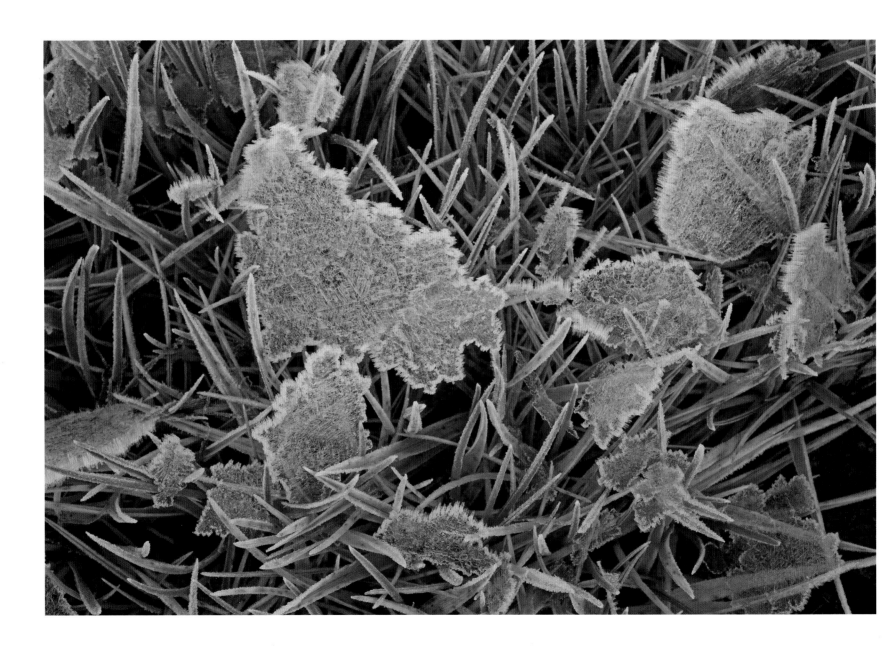

Our Beautiful, Fragile World

The Nature and
Environmental Photographs
of Peter Essick

rockynook

Editor: Joan Dixon
Copyeditor: Maggie Yates
Layout: Petra Strauch
Cover Design: Helmut Kraus, www.exclam.de
Printer: Everbest Printing Co. Ltd through Four Colour Print Group,
Louisville, Kentucky
Printed in China

ISBN 978-1-937538-34-7

1st Edition 2013
© 2013 Peter Essick

Rocky Nook, Inc.
802 E. Cota Street, 3rd Floor
Santa Barbara, CA 93103

www.rockynook.com

Library of Congress Cataloging-in-Publication Data

Essick, Peter.
 Our beautiful, fragile world : the nature and environmental photographs
of Peter Essick / by Peter Essick. -- 1st edition.
 pages cm
 ISBN 978-1-937538-34-7 (softcover : alk. paper)
1. Nature photography. I. Title.
 TR721.E87 2013
 779'.36--dc23
 2013016152

Distributed by O'Reilly Media
1005 Gravenstein Highway North
Sebastopol, CA 95472

Dedication

*To our children, grandchildren, and those generations
beyond who will inherit a complex world of wonder, promise,
and loss. I have faith that these talented people, with
their affection for life, will use the extraordinary tools of
technology to change our current direction and renew our
connection to the natural world.
This book is for you.*

Table of Contents

Foreword by Jean-Michel Cousteau

For more than half a century, my family and I and our teams have shared our discoveries and our concerns about the global ocean with the public. Any expertise we have gained has been broad, oceanic, and summarized by the creed that "everything is connected." For many it was my late father, Jacques-Yves Cousteau, and the Cousteau family who helped inspire a sense of desire to explore, to discover, and to understand the wonders of the natural world. It's ironic that in the past seventy years since my father co-invented SCUBA in 1943, we have degraded, overharvested, and changed the landscape of our natural world more than any time in recorded history. We are the primary force threatening the very fabric that holds our rich tapestry of biodiversity together. But with that knowledge comes caring and hope. It's books like Peter Essick's *Our Beautiful, Fragile World* that show us new discoveries, new knowledge, and new insights that will help heighten our understanding of the importance of the natural world to all living things, including ourselves.

Peter Essick shares his personal stories from twenty-five years of traveling to some of the most remote regions in the world to capture the perfect image to visually enhance articles for *National Geographic* magazine. His images highlight some of today's most pressing environmental issues: fresh water wars, deforestation, climate change, coral bleaching, nuclear waste, and plastic and chemical pollution. The articulation of his personal experiences with these complex issues, each story illustrated with a single image, will help shed light and give us insights on how we can begin to repair the damage we have wrought on the natural systems that support all life. Essick gives examples of how to protect the vital species and ecosystems that still remain intact. We are at the threshold of a new era of understanding.

How successful we are in securing an environmentally sound future for generations to come will depend in large part on how we move forward to protect the natural world and the myriad of resources it provides for all humanity. We are, after all, borrowing the richness of our planet's assets and investing them to ensure that future generations are able enjoy the same privileges we have been fortunate to enjoy. But we have to do it with an ecological mindset, not with a quick boom-and-bust manner fueled by greed.

The beautiful images in this book will transport you on an adventure of discovery while looking at nature at its best, with images from some of Peter Essick's favorite places, such as Torres del Paine National Park in Chile, near the tip of South America in the southern part of Patagonia. The images will also transport you to the cold reality of human society at its worst through the documentation of the depletion of biodiversity in the name of progress and development, such as what Peter witnessed and photographed in the Canadian Oil Sands and in the shameful aftermath of our irresponsible use of Agent Orange in Vietnam decades ago.

I know that when people see and feel the beauty of the natural world, they understand in a profound way the need to take care of our water planet. Creative, optimistic, inspirational people are a force for a better future. Peter Essick is that type of person, and through his beautiful images he gives us that sense of a personal connection with the planet and he inspires us to do all that we can to be a part of a sustainable future.

My father always used say, "People protect what they love." It's obvious that Peter has the passion and knowledge to communicate his love of nature through the art of photography. He desires to share his message that it is possible to live in harmony with nature. As he says in his closing remarks, "... we need to turn off our selfish genes and work together for the good of humanity and for the diversity of all the life that surrounds us."

I feel much hope for the future when I see the talented work of artists like Peter Essick and understand the message he conveys through his stunning environmental images. We no longer have the luxury of being ignorant about some of the most pressing environmental issues. Time is of the essence and that time is now. Dive in and learn all about *Our Beautiful, Fragile World*.

Jean-Michel Cousteau
President/Founder
Ocean Futures Society
www.oceanfutures.org

JEAN-MICHEL COUSTEAU'S
OCEAN FUTURES SOCIETY
WWW.OCEANFUTURES.ORG

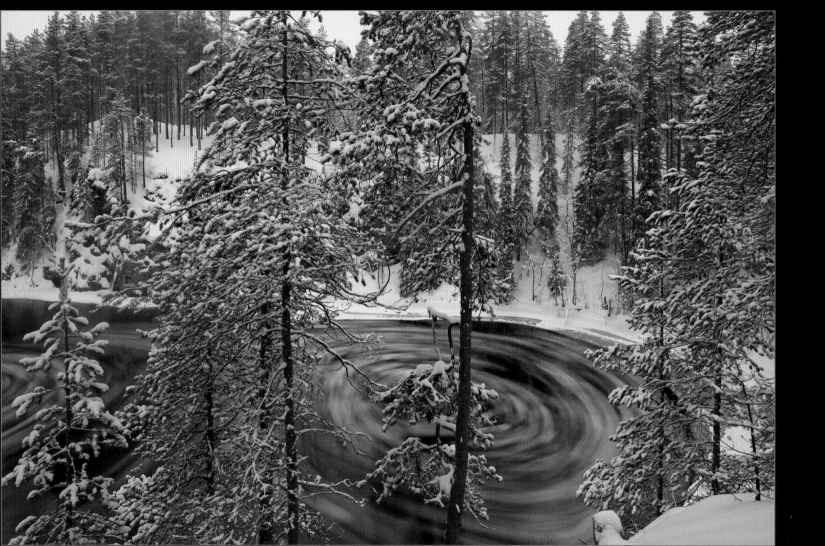

Introduction
Photographic Expressions for a Better World

The great nature photographer Ernst Haas said, "A picture is the expression of an impression. If the beautiful were not in us, how would we ever recognize it?"

From the tiniest molecules to the vastness of space, our world is bursting with beauty. The oceans, mountains, trees, flowers, people, history, and cultures all offer a view of the exquisiteness of life itself. I agree with Haas that beauty is a part of us and we are a part of nature—a part of the world.

And yet, as a photographer on the environmental beat, it's all too easy to see people in a negative light. We humans are the ones who pollute the waters and cut down the trees; our careless acts that cause harm in the name of progress can sometimes seem to be inspired by greed. Are these the same humans who are filled with beauty? I believe so.

I came to the job of photographing nature and the environment in a roundabout way, although looking back the path seems more logical than it did when I was walking on it. My father was a high school science teacher and a lover of the outdoors. Growing up in southern California, there were many opportunities to experience nature firsthand. The beach, the mountains, the desert, backpacking, skiing, river rafting—our family did them all. It's easy to see how my upbringing gave me an ability to comprehend certain truths about nature, and how my childhood prepared me for my continuing exploration of our world.

However, I was not thinking in such grand terms when I first picked up a camera. I was a shy kid, and right away photography felt like the best way for me to express myself, my best chance at making an impression. Eventually I went to journalism school and then became a summer intern at *National Geographic*. After doing a few cultural stories for the magazine, I found a niche photographing nature and the environment.

Generally, landscape stories at *National Geographic* concentrate on exceptional natural areas from around the world. The focus is on wild nature, what it looks like, and how it functions apart from the activities of man. For some, these pictures may feel like a pleasant daydream, a nice distraction from the routines of day-to-day life. I have never looked at landscape photography in that way. For me, it is important to experience nature undisturbed in order to have an understanding of how ecosystems and all that live in them are meant to be.

My environmental stories focus on the flip side of wild nature. Usually something has gone wrong. Maybe there has been an environmental train wreck where raw nature has been replaced by nuclear waste or toxic chemicals that are difficult to clean up. Or maybe it's the impact of millions of people, concentrated in one watershed or valley, which ends up contaminating a bay or fouling the air. Whatever the cause, I think it is important to photograph the results.

The photographs in this book are expressions of some of the things that made an impression on me during the last 25 years working as a photojournalist. I hope they are expressions for a better world.

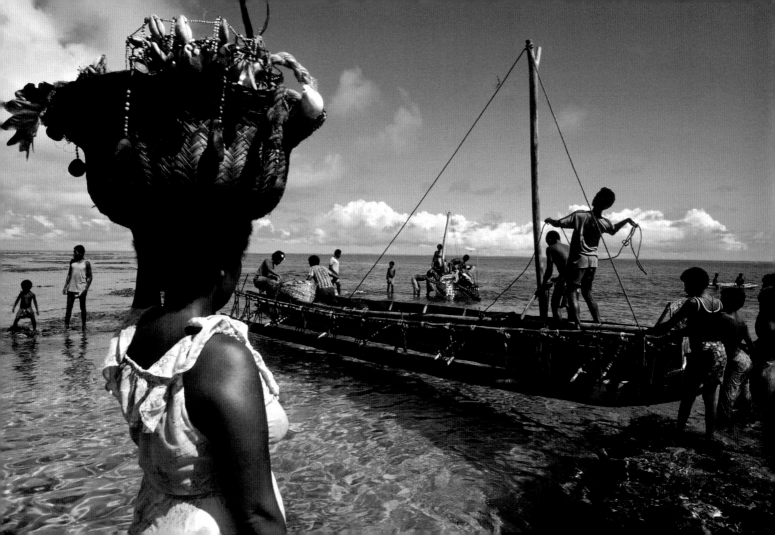

The Trobriand Islands: A Microcosm of our Dwindling Resources

To the outside observer, the Trobriand Islands are the embodiment of a South Pacific paradise. They are part of Papua New Guinea, but their culture is Polynesian. They were made famous to the outside world by Bronislaw Malinowski, the father of modern anthropology. He spent several years on the islands during World War II and established the practice of participant observation still used by anthropologists today.

I spent over two months on the Trobriand Islands in 1991 working on an article for *National Geographic*. Before leaving for the Trobriands, I read Malinowski's famous book, *Argonauts of the Western Pacific*. The now-classic book described many interesting aspects of Trobriand culture, including the kula ring, a sophisticated system of trading kula shells between islands, even though the shells carry only symbolic value.

The flight to the Trobriands took almost three days with all the connections. As luck would have it, the young man sitting next to me on the last leg of my journey was a Trobriand Islander working on his doctorate in anthropology. He had discovered what he considered to be several errors in Malinowski's work and wanted to do his research on the advantages and disadvantages of the participant observation approach. He understood what I was planning to do on the islands as a journalist, and he invited me to stay with his father in the village where he grew up.

It turned out to be an extraordinary experience. The father did not speak a word of English, but was happy for me to stay in his hut. He always had plenty of food for me and never asked for any money in return. Throughout the entire trip I ate yams and greens with some occasional fish if someone in the village had a few extras to spare. I rode around on a small motorbike with Madu, a barefoot student from the village who spoke English and served as my translator.

The experience of photographing in the Trobriand Islands, a completely different culture than my own, has helped me immensely throughout my journalistic career. However, my biggest discovery was that the Trobrianders, living on an island with a fixed amount of land and a growing population, were a perfect example of the situation we all now face. The Trobrianders have to figure out—like the rest of us—how to preserve their traditions and adapt to a world of fewer resources per individual.

I have not returned to the Trobriands, but from newspaper articles and scientific studies I have read, I know they have experienced an increase in environmental problems in the years since my visit.

An Australian Associated Press report by Ilya Gridneff in 2009 said that due to "a population explosion" the culturally important yam harvest festival has not been held for the last 20 years "because harvest sizes are not good enough to literarily sing or dance about." Also in 2009, an article by Todagia Kelola in the Papua New Guinea Post Courier[1] reported on food shortages and the ensuing social problems in the Trobriand's Milne Bay Province.

It makes me feel sad to read these accounts of a place I remember so fondly. There were some warning signs when I was there, and they seem to be coming to fruition. It might be a cliché to say there is trouble in paradise. Perhaps it is better to say that when we look at the world of the Trobrianders, we see a reflection of ourselves.

1 *Post-Courier Online*, Islands of Love in Trouble!, 2009

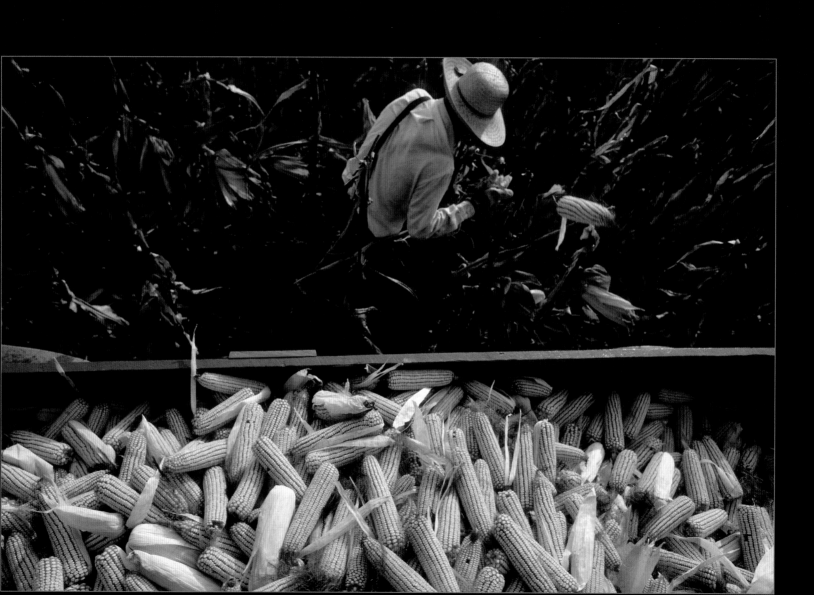

The Golden Grain: Before a Tarnished Image

There was a time when corn seemed to have only a glowing reputation. When I worked on a commodity story about corn in 1992, I felt that corn had only an upside as a food source. A journalist always tries to look for the good and the bad—even though this idea of balance is a dated one—but as I did this story, I found it hard to identify any negative aspects of corn as a food source.

Corn was first domesticated in Mexico and became the center of the culture for the Mayan and Inca peoples in South America. In Guatemala, people still worship the corn god and believe that the first people were created out of corn. In Sololà and the surrounding highlands of Guatemala, I photographed beautiful outdoor markets where villagers in traditional costume sat behind sacks filled with of multi-colored corn. In Iowa, I visited a family farm surrounded by cornfields during the annual harvest. At the Corn Palace in nearby Mitchell, South Dakota, over 20,000 ears of corn were attached by hand to the outdoor walls to form wonderful mosaics showcasing local traditions. At the annual Valparaiso, Indiana popcorn fest I even photographed Orville Redenbacher being fed his favorite food by a cute little girl.

How things have changed over the last twenty years! When I was working on the story, the idea of genetically modified corn was just being discussed. Some large corporate farms were starting to appear, but the family farm was still prevalent. Ethanol was a novelty that had been invented, but it wasn't very well known and certainly was not available at the pump. I don't remember even hearing the term *high fructose corn syrup*, even though such sweeteners were being used at the time. I did photograph a beef feedlot in Nebraska to illustrate the fact that it takes 10 pounds of corn to make one pound of beef. However, corn seemed to be a healthy food and a good crop for both for the subsistence and commercial farmers.

To me, it is a shame that corn has become a symbol of corporate greed, political foolishness, America's fast food culture, and the obesity epidemic. I believe the change came when corporate interests started to buy out the family farms, displacing families who had worked the land for generations. Corporate farming is all about maximizing profits for the shareholders. Genetically modified seeds substantially increase yields and reduce labor involved with pest control. In order for demand to keep up with the increase in supply, new uses for corn have had to be found, such as in the production of corn syrup, ethanol, and cattle-feed. Covering the environment is always an evolving story; what seemed right 20 years ago is quite different now that new information has changed the story.

The photo is of Amish farmer Robert Slabaugh harvesting corn by hand on his farm in Indiana. The Amish are unique in that they have been able to resist a lot of the rapid change happening on farms all around them, but it is hard to say whether Slabaugh or the next generation of Amish will continue to harvest by hand.

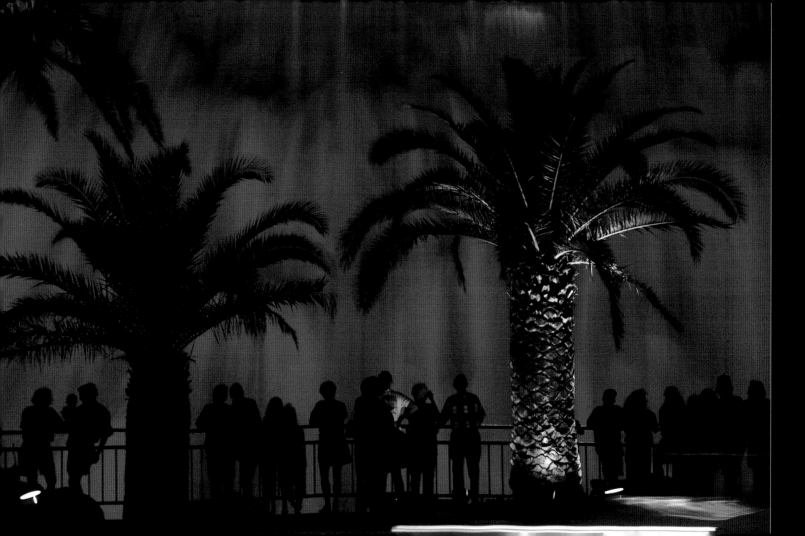

Creating a New World: Wasting Water Along the Way

The first stories I did for *National Geographic* focused on cultural issues. I was fresh out of photojournalism school and I wanted to document people in their ordinary lives and tell stories about cultures and historical events. However, in 1993, an assignment to photograph freshwater issues in North America changed the direction of my career.

The water assignment was extraordinary. Gilbert Grosvenor, president of the National Geographic Society and grandson of its founder, had decided to fund a special issue devoted to water. Since this extra 13th issue of the year was sent to all the subscribers without any advertising, it represented an investment of several millions of dollars. Grosvenor was often seen as quite a conservative man, and I think some people wondered why he was willing to invest so much on this issue. Looking back, he was right to bring the environmental issues associated with freshwater to the attention of the *National Geographic* readers.

For this assignment, I spent quite a bit of time in the southwestern USA. Tucson, Arizona was a good example of a town that was practicing efficient water conservation. Native, drought-tolerant plants were popular, and many people irrigated their landscaping with greywater, a system of conservation that reuses water from domestic activities, such as dishwashing and bathing. Phoenix and nearby Las Vegas were bad examples.

Las Vegas, in particular, was a glaring example of a city in the desert that flaunted its growth and luxurious, wasteful use of water. The nightly volcano water display at the Mirage Hotel in Las Vegas was dramatic, but seemed to be an extravagant use of water for a city with scarce water resources in the middle of a desert. In 2004, when I did a second story on the global lack of freshwater, I returned to Las Vegas where I discovered and photographed a second water show at the Bellagio Hotel.

Overall, Las Vegas is one of the strongest examples of American excess. It is a city where the pursuit of instant gratification and wealth is seen as a worthwhile venture, while the environment can be damned.

In 2005, in an effort to change its image, the city offered the casinos heavy green incentives. The strip can now boast about many Gold and Silver LEED certified buildings that have been retrofitted for energy and water savings, but I am sure that Las Vegas could find many more ways to reduce its environmental impact.

For me, the photographs I have taken to illustrate environmental issues have a special meaning. They have often had several lives beyond the *Geographic* story they were originally made for, usually in textbooks or to illustrate other editorial stories. I have even sold fine art prints of images of nuclear waste sites and mine tailings, although my landscape photographs of natural areas are more popular with collectors. In recent years, scientists have named this era of natural history the Anthropocene, a geologic age where man has taken control of the Earth's biosphere. A growing number of photographers are devoting their creative talents to photographing life in the Anthropocene. These types of photographs can have several layers of meaning, and they ask questions about what we humans are destroying in the name of progress.

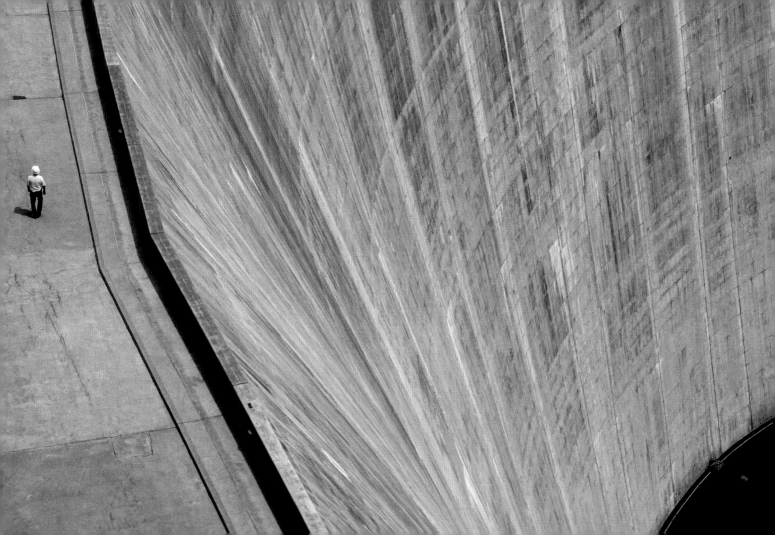

No Dam Good: Too Many People

The 1993 *National Geographic* special issue on freshwater was broken up into four parts: Supply, Development, Pollution, and Restoration. I worked primarily on the first two sections. The story about the development of water resources in the USA focused on the history of dams built in the West.

From the 1930s to the 1960s dams were seen as the solution to water shortages and periodic flooding in the desert environment. On top of that, dams provided power, irrigation sources for farmers, and nice reservoirs for summer recreation. Humans could now harness the forces of nature for the good of civilization. However, by the 1990s when I did this photograph of the Glen Canyon Dam, there had been a realization that there was a negative aspect to dams, as well.

Environmentalists and nature lovers will first point out the destruction of the natural landscape behind the dam. In the case of Glen Canyon, the Colorado River and various side streams had carved some amazing slot canyons in the desert sandstone. The famed photographer Eliot Porter did a book on the canyons, called *The Place No One Knew,* as the reservoir was filling up. When the dam was approved in the late 1950s, this was a dry, remote location that was probably thought to be expendable. We are now beginning to see that natural places like those slot canyons are special and unique.

The dams that were built on the Columbia River in the Northwest blocked salmon runs. Some of the dams installed fish ladders to limited effect, but most did not. In one famous statement, Floyd Dominy, the commissioner for the Bureau of Reclamation from 1959–1969, remarked that people could live without salmon but they couldn't live without farms and water for irrigation. It didn't seem to matter in his mind that salmon were an important part of the ecosystem.

In recent years, there has been new understanding about just how damaging the dam-building era was. Dams such as Glen Canyon were built primarily to provide a reliable source of water for the nearby population. As that population continued to grow exponentially, it became apparent that there just was not enough water in the Colorado River to provide the comfortable American lifestyle for them all. Scientists and water managers also discovered that much reservoir water evaporates in the desert heat before it can ever be used. There is also the problem of silt: all the sand from erosion that was naturally carried by the muddy Colorado was now clogging waterways behind the dams. It was calculated that the reservoirs would eventually fill up with sand, leaving little room for water.

We can't just rely on big dams to provide for our needs. On a small scale, a little community may be able to install a micro dam in a remote location to good effect, but the large-scale dams that block major rivers carry too high an environmental and cultural price. The bigger message is that humans can't harness nature; we can only learn to live within it.

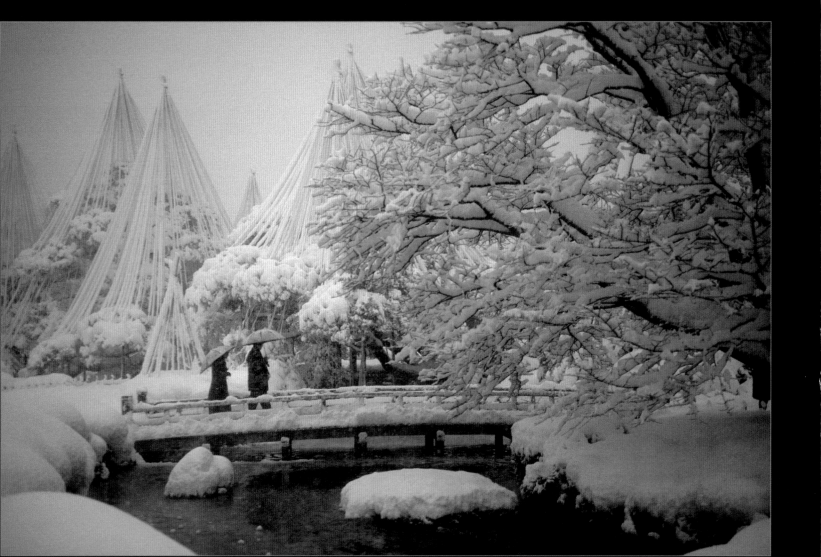

Inner Japan: Zen and the Art of Living Close to Nature

To the east of the Japanese Alps, which divide the island of Honshu north to south, is a place that is special in Japanese culture. Many of the traditional elements of Japanese culture originally came from China and Korea through this beautiful corner of the world. Perhaps a better way to describe it would be to quote the caption on the opening spread of the article in the September 1994 issue of *National Geographic*:

"There is a land not far from Tokyo, yet a world apart from Japan's industrial epicenter. It is a quiet place where tradition matters, simplicity is a virtue, and beauty still blossoms from the milky glaze of Hagi-yaki pottery. This is ura Nihon—the world of Inner Japan."

Shinto, which roughly means "the study of the spirits," is the indigenous religion of Japan. The spirits can be rocks, trees, rivers, or people who are connected to nature. Garden cultivation is another expression of the traditional Japanese view of nature. This photo is of Kenroku-en, one of the Three Great Gardens of Japan. Located in Kanazawa, the garden was developed from the 1620s to the 1840s. It was originally the private garden of the feudal rulers, or daimyo, of the Maeda clan, who were the second most powerful clan in Japan at the time. In Japanese, Kenroku-en translates to "garden that combines six characteristics." According to the ancient Chinese book of gardens, there are six features that all gardens should have. The features are grouped into three pairs: spaciousness and seclusion, artifice and antiquity, and watercourses and panoramas. The concept of artifice and antiquity is particularly revealing of the Japanese relationship with nature. It is explained on the official Kenroku-en web site as:

"The very idea of a formally sculpted garden is such that its form should seemingly break the ancient patterns of nature as a matter of course. Kenroku-en is nothing if not artificial in the extreme, and yet, somehow, all the artificial effigies, the carefully placed weathered rocks and artfully trained aged trees have grown together naturally."

To me, Kenroku-en is especially beautiful in a winter snowstorm. Inner Japan receives heavy snowfall from storms that originate in Siberia and pick up moisture as they cross the Sea of Japan. I feel fortunate that I had the opportunity to photograph this remote land, a region visited by few tourists, especially in winter. In addition to my photography, I was inspired to write a haiku about my experience at Kenroku-en:

Winter morning walk
heavy snow in Kenroku-en
beauty elements

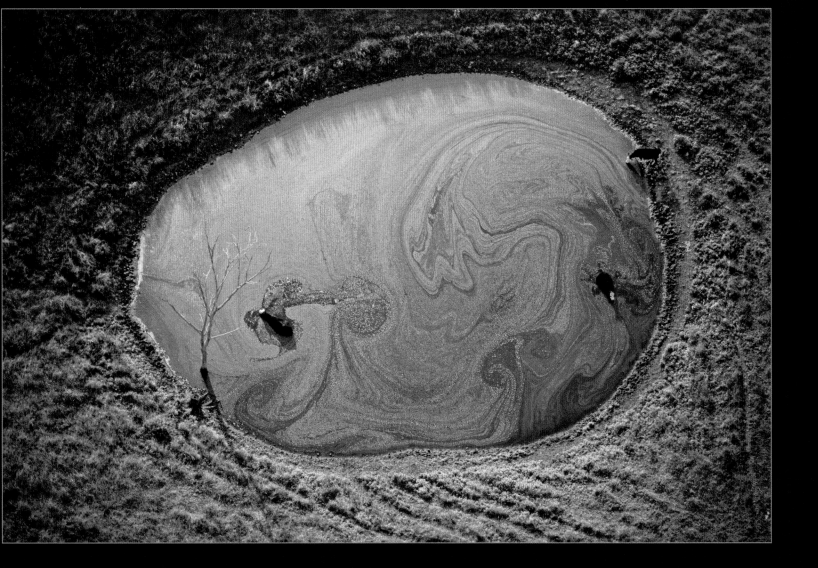

On the Environmental Beat: Finding a New Voice

Following the large coverage for the special issue on freshwater, I did a smaller story on the same topic. This time I wanted to photograph a particular aspect of the issue of freshwater that was not covered in the special edition—nonpoint source pollution.

Scientists had discovered that up to 80 percent of the pollution in waterways didn't come from municipal or industrial pipes—so-called point sources. Instead, it ran off the parking lots or farms within the watershed area. The *National Geographic* article called this polluted runoff "widespread as rain and as deadly as poison." It has now been acknowledged that understanding this phenomenon is key to controlling water pollution in developed areas.

I worked with picture editor Dennis Dimick on the story. It was the first of many environmental stories I would do with him in the following years. Dennis felt that a picture editor should not only pick the best photos, but also support the photographer both artistically and emotionally.

The editors considered the story on nonpoint source pollution to be a difficult one to depict visually, and nothing similar had been done before. I thought it was great to work on a story where there was no precedent. When I started to do the research, I realized there were quite a few places where the effects of this type of pollution were evident, even though they were not blaring or obvious. It was up to me to photograph them in a way that was as visually interesting as possible.

Sometimes I experienced artistic quandaries trying to make good pictures of bad issues, but I learned that the principles of lighting and composition remain the same, regardless of the subject. Eventually I came to the realization that a different aesthetic might be required to convey negative situations honestly, but at the time, my original approach worked well. Dennis used the term "terrible beauty" to describe the best illustrations of environmental issues, and I like the phrase very much.

I was always drawn to stories that had a message. I did this particular story when I started focusing on environmental stories of social importance. Not all stories stand the test of time, but when I look at this story today, I'm still proud that I reported on something important and worthwhile. It may sound a little self-important, but I believe that artists should try to document the truth as they see it, even if those truths are unpleasant; the job can be difficult at times, especially trying to get access to polluted areas, but the results are quite rewarding.

The photo is of a sinkhole near Bowling Green, Kentucky. The vibrant green color is algae caused by the runoff of excess nitrogen from fertilizers. The cows in the water, of course, pollute as well.

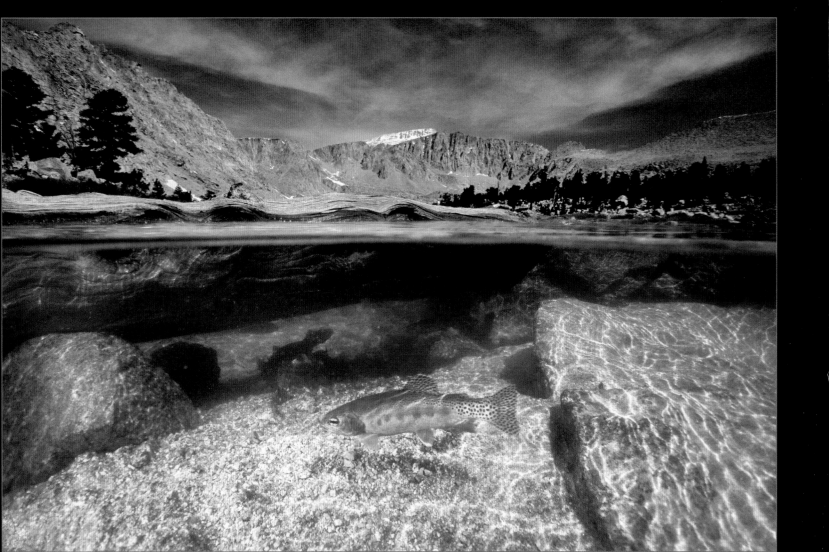

Fish Story: Clean Water and Well-to-Do Anglers

Kent Kobersteen, who was then the Assistant Director of Photography at *National Geographic,* called and asked if I was interested in doing a story about trout. At the time I was up for almost anything that involved photography, and this seemed like another way to cover freshwater issues and the outdoors.

There was a definite environmental angle to the story. Trout require cool, clean water and healthy insects to thrive. When trees are cut down along streams, the loss of shade increases water temperatures. Logging can result in silt, which runs into the rivers and clogs the clear water that trout love. But a story on trout also involves the recreational angle of the culture of people who are almost religious about the sport of fly fishing.

When I started to do the research for this aspect of the story, I realized pretty quickly that I didn't know the first thing about fly fishing, and that I needed to learn fast. I discovered the Al Caucci Fly Fishing School in West Branch, Pennsylvania, and I signed up as a student.

The school turned out to be a great place to start my research for the story. The fishing location on the Delaware River, between the Endless Mountains in Pennsylvania and the Catskills in New York, is fabulous, and Al Caucci is a great evangelist for the art and science of fly fishing. He preaches the gospel of "match the hatch," which involves determining which insects are in the river at different times during the spring and summer, and then using the appropriate flies on your line. The participants practiced on the lawn of the Delaware River Club, learning the unique casting motion necessary to becoming accomplished fly fishing anglers. By the end of three days at the school, I was talking the lingo and Al had sold me a new fly rod.

However, I discovered that some fly fishing involved a whole different class of people than I was used to or comfortable with. Fly fishing has its roots in England, so a trip across the Atlantic was in order. My first stop was the Houghton Club on the River Test, the most exclusive fly fishing club in Britain. Here, it didn't matter if you knew how to talk trout; to be accepted, you had to be born with the right color blood. Unlike in the United States where waterways are public, the Test was private property. At the Houghton Club, the river keeper catches the fish, and the member reels them in before going back to the clubhouse to drink and socialize. The trouters at the nearby Arundell Arms sporting hotel were almost as snooty, but at least they did fish for themselves. Overall, the experience proved difficult for me to navigate at the time, but I managed to get the needed photographs.

Life seemed better when I went to California to photograph in the Golden Trout Wilderness. I was back in familiar territory in the High Sierra range. For this image, I used an underwater camera to capture the beautiful golden trout spawning in the high alpine rivers and streams.

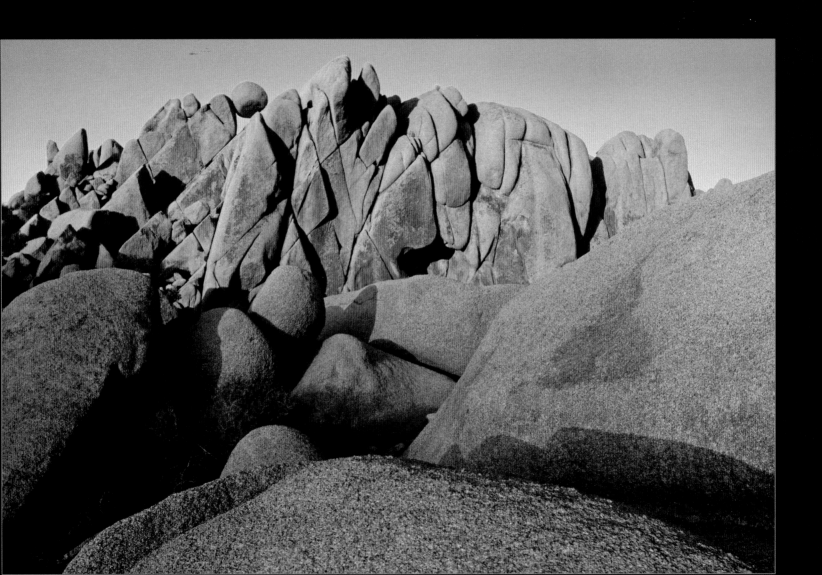

California Desert Lands: The Sublime and the Desolate

In 1994, President Bill Clinton signed the California Desert Protection Act. It was a sweeping legislation that involved over 9 million acres. It created and gave federal protection to the Mojave Preserve and many other new wilderness areas. There were provisions to protect the endangered desert tortoise as well as protection for habitats of rare dune grasses, burrowing owls, and desert bighorn sheep. This act was symbolic of a new attitude toward this arid ecosystem, and it gave me a good excuse to do a story on the California desert.

For me, this was an almost perfect assignment. I grew up in southern California and was familiar with the nearby desert regions. I was especially fond of Death Valley; I'd made several trips there with my camera when I was first discovering photography. I had also photographed in the region near Joshua Tree National Park.

When I was in college, I bought a 1961 International Scout four-wheel drive especially for trips to the desert. It ran fine after my father and I rebuilt the engine, and I took it through several canyons in Death Valley that I could never have explored in a regular vehicle. I also drove to the top of one mountain ridge in the eastern part of the park, and slept in the jeep so I could take sunrise photos the next morning. What I hadn't anticipated was the temperature falling below freezing at night; when I tried to start the car in the morning, nothing happened. I hadn't put any anti-freeze in the radiator after the rebuild— just water—because I was low on funds and figured I wouldn't need anti-freeze in Death Valley. Fortunately, a fellow seeker of solitude happened to wander by a few hours later. He told me to take off the fan belt and slowly warm up the engine to melt the ice inside. It worked, and I carried on and drove all the way home!

On this story, I learned that locals often view environmental legislation like the Desert Act quite differently than those living in the nearby cities. For people like Howard Blair, a rancher who leased 400,000 acres in the Mojave Preserve, the Desert Act was a threat to his livelihood and way of life. The formation of new parks often requires people who own property in the affected areas to sell their land to the government. This became an important part of the story for me to cover; it's crucial to understand the point of view of those who make a living off the land, not just those who enjoy it on the weekends.

The California Desert story was my first attempt at putting a series of pictures together to tell a story about a place. In journalism school, I had done many picture stories about people or cultures, but this story was about the poetry of the land and the types of people who are drawn to it. There is an art to sequencing pictures so that the series has just the right balance, flow, color, and design to pull the reader in—I tried to capture a cross section of the places affected by the Desert Act to make people fall in love with the desert and the sublime beauty of desolation.

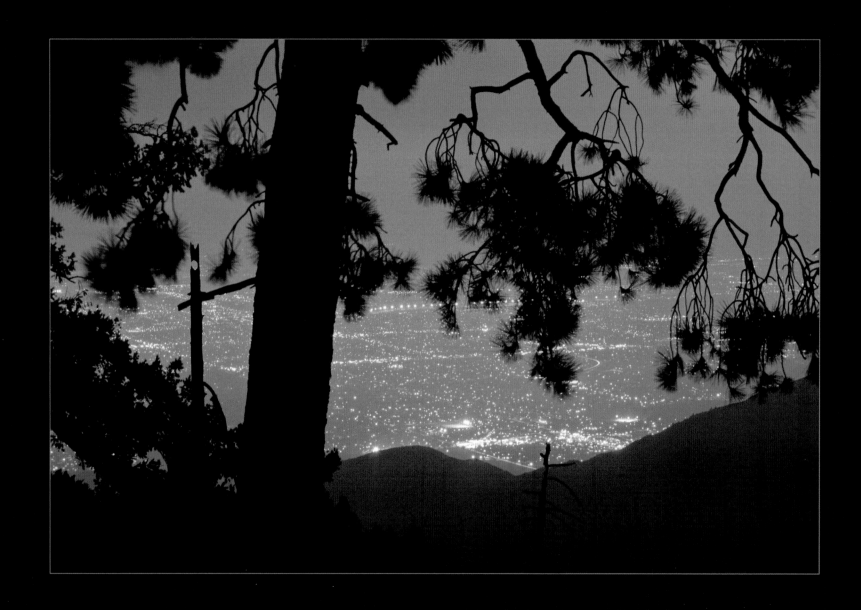

Our National Forests: Spotted Owls and Smog-Stressed Trees

If President Bill Clinton had been the hero of the California Desert article in *National Geographic* in 1994, his reputation took a hit when the story about the U.S. National Forests came out two years later. Politics had reared its ugly head, and what had worked in legislation to protect the remote California desert lands couldn't be duplicated on a national level. This was especially true in the Pacific Northwest, where loggers didn't want similar legislation affecting anything in their neck of the woods.

The National Forests in Washington and Oregon became the center of the battle between loggers and environmentalists in the 1990s. Due to their declining numbers, the spotted owl had been placed on the endangered species list. It was discovered that the reason they were endangered was that they preferred old-growth forests, which were being cleared by logging operations. In order to protect the owls under the law, most of the Forest Service land in the Northwest became off-limits to logging.

The Clinton Administration came up with a compromise that initially seemed to appease everyone. Logging could take place on lands that had been damaged by wildfire, flooding, severe wind, disease, insect infestation, or any other natural disturbance. Unfortunately, this so-called salvage logging was a practice that was often abused because there were very few scientific parameters to define areas appropriate for cutting. Loggers could declare just about any forest to be in need of salvaging, and start clear cutting. Environmentalists became outraged, and some tried civil disobedience to save the forests in danger.

This war in the woods provided the political backdrop when I photographed for the National Forests article in 1996. I photographed one group of protesters in the Willamette National Forest who blocked a proposed timber sale by camping on a logging road and putting up a fortress-like blockade complete with a moat and a drawbridge. After a 344-day standoff, the timber sale was cancelled and the environmentalists declared victory. I also photographed loggers cutting old-growth trees under the guise of salvage logging. It was painful for me to watch as the trees fell in the name of economic progress and political gamesmanship.

The National Forest system is huge, and now includes much more than just forests in the West. It took quite a bit of planning to illustrate a representative sample: my series of photographs included a ski area in New Hampshire, a rainforest in Puerto Rico, a remote river in Oregon, and a shooting range in southern California, all of which were locations within a National Forest.

Gifford Pinchot, the first Chief of the Forest Service, believed that many of the forests in the United States could be managed as a renewable resource. This idea seemed reasonable during his 1905–1910 term, but as the population grew, the pressures on the finite resources of the forest became unsustainable. Now the forests, like these smog-stressed trees in this photograph of the San Bernardino National Forest near Los Angeles, are suffering the ill effects of too much development—just like the citizens in the city in the background.

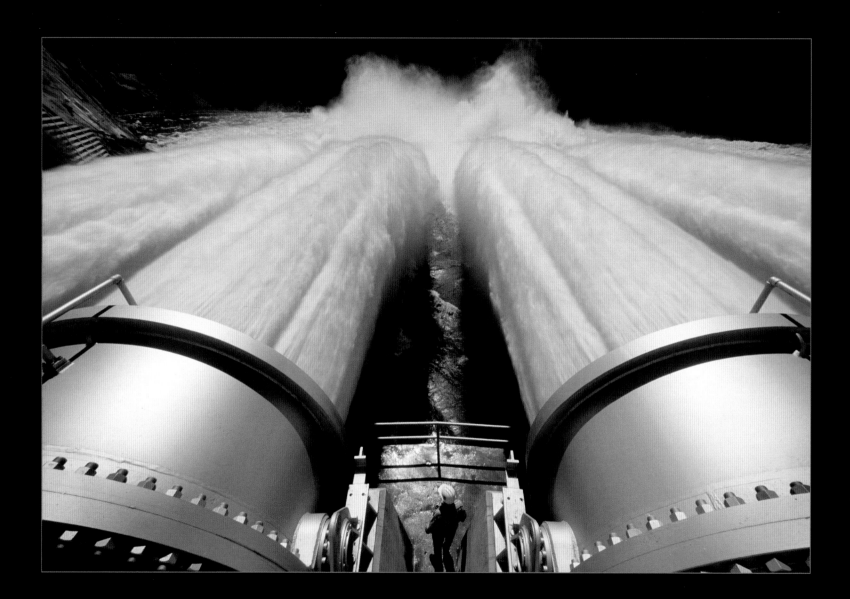

The Colorado: A River Not Quite as Grand

I was able to take two rafting trips through the Grand Canyon when I photographed a story about an experimental artificial flooding of the Colorado River in 1996. In March, the floodgates of Glen Canyon Dam upstream were intentionally opened wide for seven days. The idea was to simulate the annual flooding that used to happen every spring before the dam was built.

The Colorado River carries a big load of sediment that builds up the beaches in the Grand Canyon. The river rafting companies had noticed that since the dam was built in 1962, the beaches had been slowly eroding away, leaving little room for the rafters to camp. But there were other unforeseen environmental effects downstream from the dam that were more significant than inconvenienced rafters. The post-dam banks had become filled with exotic tamarisks and native willows that were growing closer in to the river than was ever possible during the time of annual floods. This riparian vegetation teems with insects; the insects draw birds, which are preyed on by peregrine falcons. The native humpback trout that favors the silty waters is now outnumbered by rainbow trout, a favorite meal of bald eagles.

The building of the dam transformed the entire area into an artificial ecosystem. Managing the wilderness by allowing an artificially induced flood to repair damage caused by the dam was a solution that caused new issues. For example, at Vaseys Paradise, the endangered Kanab amber snail had grown accustomed to a diet of watercress, an introduced plant living by a cliff-side spring. Hundreds of these snails had to be moved to higher ground during flooding.

During my first trip, I photographed the flood from a large, motorized, rubber raft. The idea was to see the effects of the flood while it was happening. We had to move quickly to get through the whole canyon in a week. During this trip, the water was at its highest level since the building of the dam. It was interesting to experience, but it turned out not to be the best opportunity for photography.

The writer of the article, Mike Long, and I arranged to go on a 17-day trip down the river on a dory boat about six weeks after the flood event. The stated purpose of the trip was to see if the beaches had been built up as projected, but I think we both really just wanted to go on a dory trip. The legendary guide and environmentalist, Martin Litton, came out of retirement for the umpteenth time to go with us. It turned out that the flooding did succeed in building back the beaches, but the effects were minor and short-lived, unlike those of the dam itself.

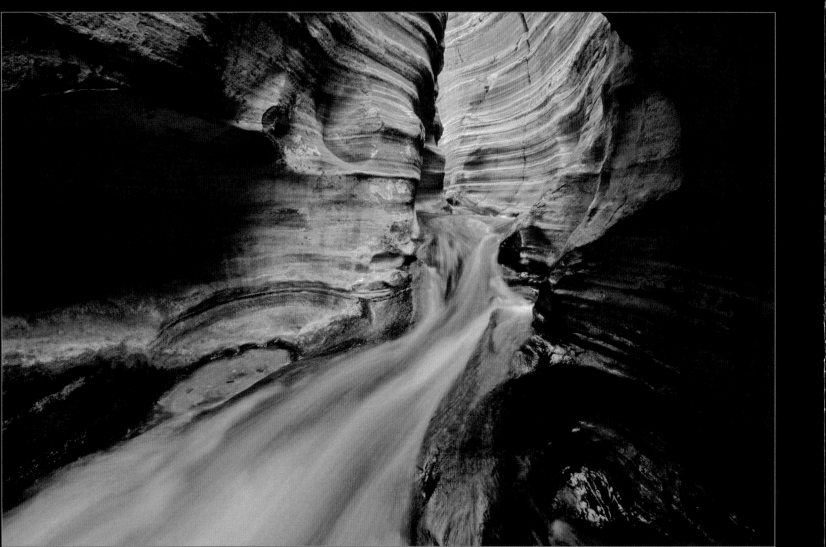

Mother Nature: The Perfect Collaborator

Edward Weston said, "Good composition is merely the strongest way of seeing." He was probably reacting to the various rules of composition that are taught to photography students. Some of these, such as the rule of thirds, may be helpful for students in the beginning, but as one grows as a photographer, these rules are usually discarded.

For me, composition is an effort to find balance. When I look through the viewfinder, I begin by first including, then excluding elements. With a zoom lens, this can be done quite quickly. I can then move left or right to test how the elements overlap. I usually take an exposure right away based on my initial reaction to the scene. Then I check the digital image on the back of the camera and look for any distracting elements. What usually bother me the most are the light areas near the edges of the frame that distract the eye from the central theme of the photograph.

After I have an image that I am pleased with, I try to experiment with a totally different composition to see if other approaches work well with the subject matter. This might be a more edgy look, a different viewpoint, or the use of selective focus. Sometimes I even like the experiment better than the original.

This photograph of Deer Creek in the Grand Canyon is an example of a composition that I saw right away. I hiked up to Deer Creek during my 17-day dory trip though the canyon. There are many wonderful side canyons and creeks that lead down to the Colorado River, and Deer Creek is one of the best for photographing. It is a classic slot canyon that is not very deep—the walls are only about 20 feet high. One can photograph it from above, or just climb right into it. To find balance, my gaze travelled through the negative spaces of the cliffs in shadow to the indirect light hitting the sandstone up the creek. My effort to compose the scene was minimal because the processes of nature were doing much of the composing for me. Ansel Adams once said that nature had no forms and was only a vast, chaotic collection of shapes. It was up to the artist to create configurations out of the chaos. I agree with the master, but perhaps in some instances the shapes are more easily converted into form.

I wondered what caused the canyon to look the way it did. Was it the differing levels of rainfall each year that caused the variations in the canyon's width? What caused the indentation where I was standing? Maybe it was a softer, different kind of limestone from a different climate in an ancient sea? Sometimes the mysteries of nature are just as compelling as the explanations. I'm glad that I could collaborate with such an amazing artist as Mother Nature.

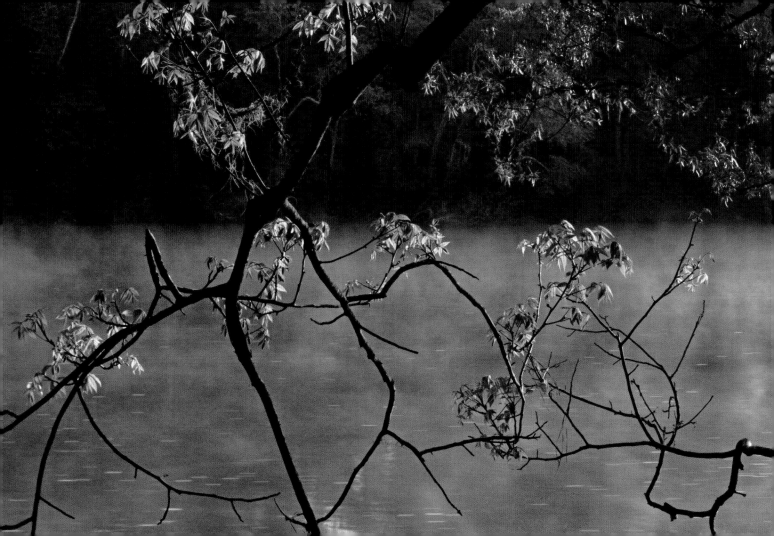

Easy Ways of the Altamaha: Time to Reflect

The year 1997 brought some major changes to my life. For starters, I got married and moved from Brooklyn, New York to Atlanta, Georgia. My better half, Jackie Sweatt, is from Indiana, but she had been living in Atlanta after graduating from Georgia Tech, working in her chosen field of city planning.

That same year, my father passed away suddenly from a heart attack. He was one of the biggest positive influences on my life. He was a high school science teacher for 44 years and loved jogging, health foods, camping, downhill skiing and backpacking, in an era when those recreational activities were far less popular than they are today. I believe my father viewed his hobbies not just as recreation, but also as spiritual pursuits to keep in shape and to feel the presence of God in nature. It is easy for me to see that I got my love of science and the outdoors, and my curiosity about the workings of world, from him.

The passing of my father hit me pretty hard. An assignment to do a landscape story about the Altamaha River in southern Georgia was the perfect remedy. The Altamaha region is a beautiful place to photograph and unwind, and it was within driving distance of Atlanta, my newly adopted home. I felt I needed some time to slow down and reflect. By that point in my career I had become a contract photographer for *National Geographic*, which meant that the editors liked my photography and I was guaranteed work. As a result, I had been traveling constantly and spent a majority of my time on the road.

While taking pictures for the Altamaha story, I discovered that photographing nature was an important part of my healing process. The five weeks I spent alone in a cabin near Darien, Georgia, allowed me to honor the memory of my father by immersing myself in the quiet, natural beauty that he loved so well. Most mornings I could get up early and drive to a scenic location for sunrise. If I felt my photographs were successful, it was great to have breakfast knowing that I had already had a productive day.

The Altamaha watershed was a different landscape than what I was used to. There were no big mountains or deep valleys. The main attraction is the peacefulness that comes with the open water, the lush green trees and plants, and the abundance of shorebirds, both resident and migratory. Most of my photography had to be done from a boat, or knee-deep in mud or sand. I discovered that photographing from the front seat of a twin kayak provided not only an unusual angle; it also got me closer to the wildlife.

For that story, I worked closely with the Altamaha chapter of the Nature Conservancy. They had done a great deal of work buying large tracts of land to protect areas that had been heavily logged since the 19th century. It is now possible to float down the whole Altamaha and only see land that is protected from development.

In the end, the Altamaha proved to be up to the task of speaking to my heart, which was both broken and expanding. The therapeutic powers of nature had worked for my father during his fruitful life, and now they had worked for me on the Altamaha.

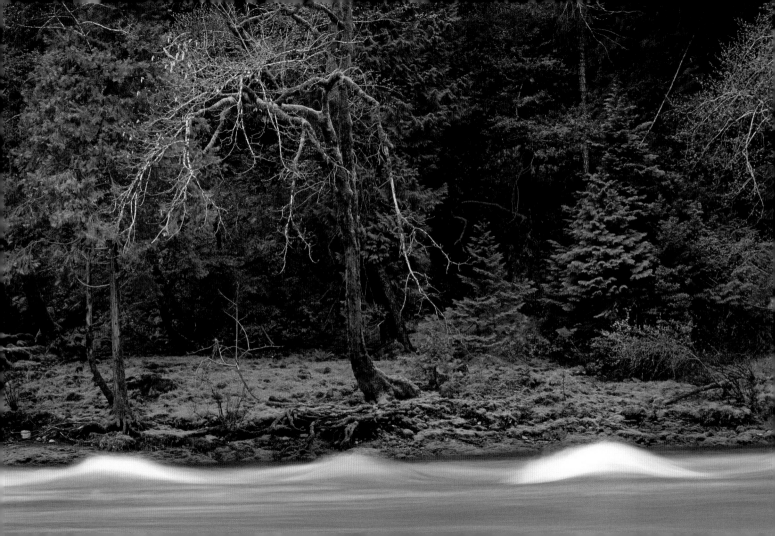

American Wilderness: A System Like No Other

On September 3, 1964, President Lyndon B. Johnson signed the act that created the National Wilderness Preservation System. It had taken eight years and 66 drafts to get the legislation passed. The Wilderness Act established 54 Wilderness Areas in National Forests in 13 states. This act, written by Howard Zahniser of the Wilderness Society, declared that "A wilderness, in contrast with those areas where man and his own works dominate the landscape, is hereby recognized as an area where the earth and community of life are untrammeled by man, where man himself is a visitor who does not remain."

I believe the idea of wilderness is one of the great inventions of the 20th century. This was the first time in the history of the United States that a government acted on the realization that some land needed to be protected from development and left alone. Up until that time, most U.S. laws were enacted to encourage development and the use of natural resources. There are a few examples from world history going back to the Babylonian and Chinese Empires where natural areas were protected, but the Wilderness Act is significant in the context of the 200 years of the Industrial Revolution that preceded it. The Act signified that a powerful, industrialized country like the United States had realized the need to set limits to expansion and growth.

The Wilderness Act afforded greater protection to natural areas than even the establishment of the National Parks System, which was seen as a way to preserve areas of exceptional scenic value for peoples' enjoyment and inspiration. In contrast, Wilderness areas were created to protect the non-human species. This was a great leap forward in environmental thinking.

In the half-century since the establishment of the National Wilderness Preservation System, the number of protected acres has increased exponentially. There are now over 700 Wilderness Areas in the USA and more are continually being added. But even though the size of the National Wilderness Preservation System has grown, it is still only a small fraction of the country as a whole. Only about 2.7 percent of the contiguous United States is protected as a wilderness area.

Scientific studies increasingly show that we may need more acres of protected Wilderness Areas in order to save endangered species and keep some ecosystems intact. The study of various facets of wilderness ecosystems usually reveals a complexity and richness that has evolved over millions of years, but is fragile to sudden change. Most scientists view Wilderness Areas as vulnerable to development at the edges. On the other hand, some futurists view Wilderness Areas as a possible last refuge in the event of a catastrophic ecosystem collapse from climate change or nuclear war.

Photographing the story on the National Wilderness Preservation System was a turning point for me in how I approached a story. In order to give a representative overview of the system, I selected 10 Wilderness Areas from diverse ecosystems around the country. I could spend one week in each, including travel time. This meant I could only see a fraction of each area in the sample. I decided the best approach was to hike into an area and stay for 3–4 days. This allowed me to set up a base camp and learn the lay of the land and the lighting conditions throughout the day. This produced better visual results than trying to see everything. I also did an aerial photograph of most of the Wilderness Areas. This photo is of the Kalmiopsis Wilderness in Oregon, one of the wildest and most biologically diverse areas in the lower 48 states.

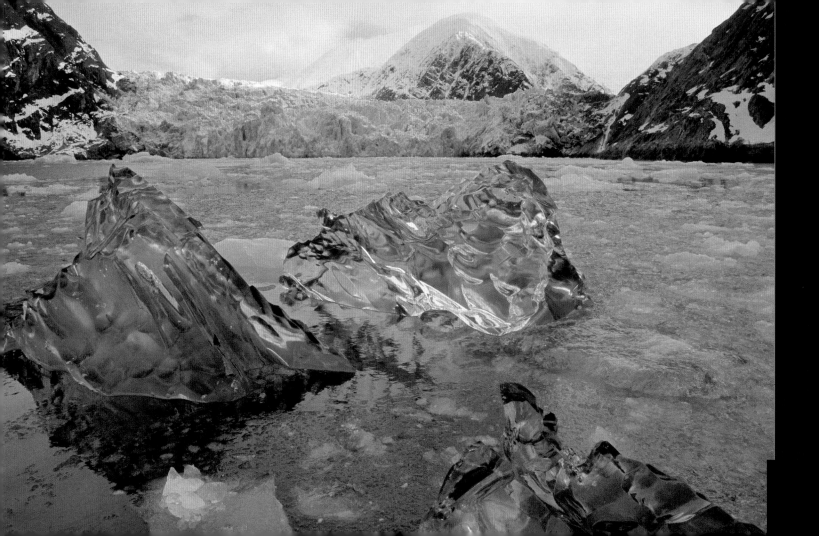

Dangerous Work: A Close Call in Tracy Arm, Alaska

It was 17 degrees F on the day in March that I hired a floatplane to take me from Juneau, Alaska, to the Tracy Arm Wilderness. A few days before, I had flown over the tidewater glacier and had seen some beautiful icebergs floating in the seawater. I wanted to photograph the icebergs up close and get the glacier in the background.

After talking to the pilot, I learned that a floatplane couldn't safely land near the glacier because of the many icebergs. The closest place the plane could land was about a mile down the fiord. I decided to be flown in near the glacier, and then to put on a cold weather dry suit, pump up a small inflatable boat, and paddle up close to the glacier. I went to a dive shop in Juneau (yes, some people do dive in Alaska) and was able to convince a dive master to go with me the next day.

The following day we flew to Tracy Arm and landed on the seawater. I was pumping up the boat when I noticed the plane starting to tilt—the float on the plane was filling up with water. The pilot yelled for us to throw everything back in the plane so we could try to take off, but the water in the float was already too heavy. Eventually, the plane started to sink about 100 feet from the bank of the fiord. The pilot said we would have to swim to shore, and I spotted a small snow bank, the only somewhat-level place where we could climb out of the water.

I had to make a quick decision of what to take with me. Should I take food and survival equipment, or save the thousands of dollars of camera equipment that was in the back of the plane? I took a small bag with one camera and lens and tried to throw it to shore. It landed short, in the water, but I was happy when I learned that the case both floated and kept my equipment dry. The pilot threw a knife towards the shore and it landed in the snow bank. Then the pilot, the dive master, and I all jumped in and swam for shore in the freezing water.

We were dangerously cold from being soaked, but as it turned out, the knife had a lighter in the handle. We were able to use the lighter to make a fire and warm our freezing fingers and toes. About eight hours later, another plane from the same Juneau flight service came and rescued us. The next day we went back with a barge and salvaged the plane, though it was considered a total loss after being submerged for a day in the salt water. The following day, I flew back to the glacier and took the picture I had originally envisioned.

I am often asked if the work I do for *National Geographic* is dangerous. I always answer that I don't cover wars or go to combat zones working on feature articles. Statistically, the most dangerous part of my job is driving in cars in various countries in unfamiliar settings. However, when I think back to my experience in Tracy Arm, I realize I was in a truly dangerous survival situation. It turned out the pilot had made a huge error in forgetting the drain plug of the plane's float, but he probably saved the three of us by realizing the importance of that lighter in the handle of his knife.

The photo was published in 1998 in an article on the American Wilderness system.

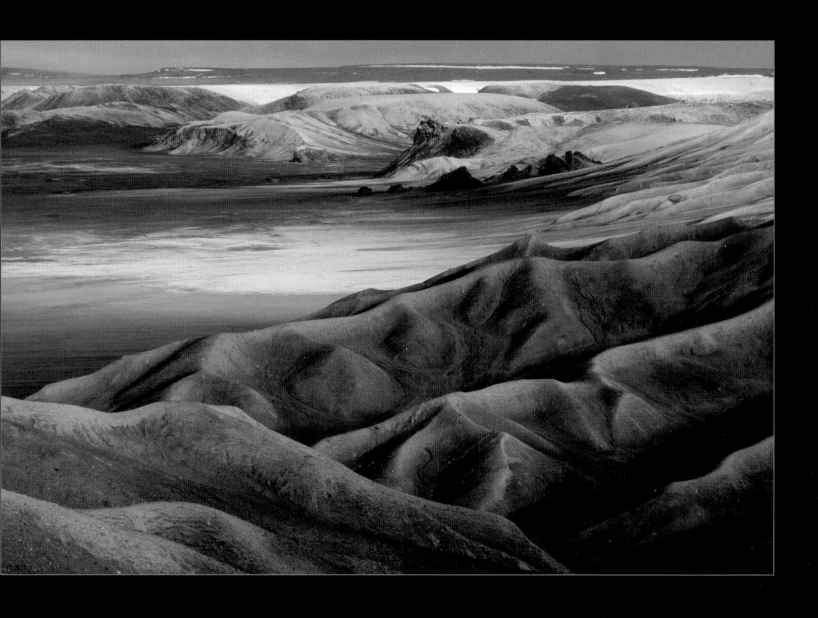

A Trip to Mars: Exploring Wilderness in the High North

Houghton Crater is a lonely place. It was created 23 million years ago when a meteor crashed into what is now Devon Island in the High Canadian Arctic. Most people would see this place as a treeless wasteland, but for a couple dozen young scientific researchers and space enthusiasts, it is heaven. In more scientific terms, Houghton is the best analogue to Mars on Earth, because it is the highest latitude impact crater on the planet. This makes it the perfect place to study how to explore Mars in the future, and how best to search for life there.

For this month-long expedition to Houghton in the summer of 1998, we had to first fly to Resolute on the Canadian island of Cornwallis. It is the only place I have been where the jet lands on a dirt runway. There is not much to do in Resolute except stock up on supplies at a Canadian polar research facility. From Resolute, we flew in a hired Twin Otter with a ton of gear to a camp inside the crater. We had to bring everything we'd need for a month, since the only other animal life forms in the crater are polar bears, musk oxen, caribou, arctic hares, and snow buntings. On the first day, we set up camp in the crater. We got instruction on how to drive an ATV and how to fire a shotgun in case we encountered a polar bear.

Besides the unique landscape, another facet of the story turned out to be the eccentric, highly intelligent scientists that this place attracted. Most of them shared a similar life goal: to one day go to Mars. The role of science was important to them, but they all were driven by a sense of adventure and exploration. They may have been social misfits in the outside world, but among their fellow believers at Houghton, they seemed to thrive.

Part of the experience was to see how well everyone fared in isolation, which is an important psychological component of space travel. After a few weeks in Houghton, I found myself having weird dreams and remembering obscure events from my childhood. Part of the difficulty is being away from your normal surroundings, and after a while, the gray, treeless landscape looked bleak.

The landscape photographs were somewhat difficult, both because of the lack of color and the fact that there was never any golden light. At 75 degrees north, the sun would only drop slightly at around 2 a.m., and it never fell below the horizon. There was only one time, during a snowstorm, that the atmospheric mood changed. After the storm, the soft light was magical. I hurried to a high vantage point on my ATV in order to get the shot, which turned out to be the lead picture.

Afterward, I didn't keep in touch with the scientists I met at Houghton, but I enjoyed the friendship and love of exploration we shared during our month together. The dream of humans someday walking on Mars remains alive, but delays and budget cuts mean that none of the people I photographed will ever walk on the red planet. I guess they will have to be satisfied with exploring Mars on Earth.

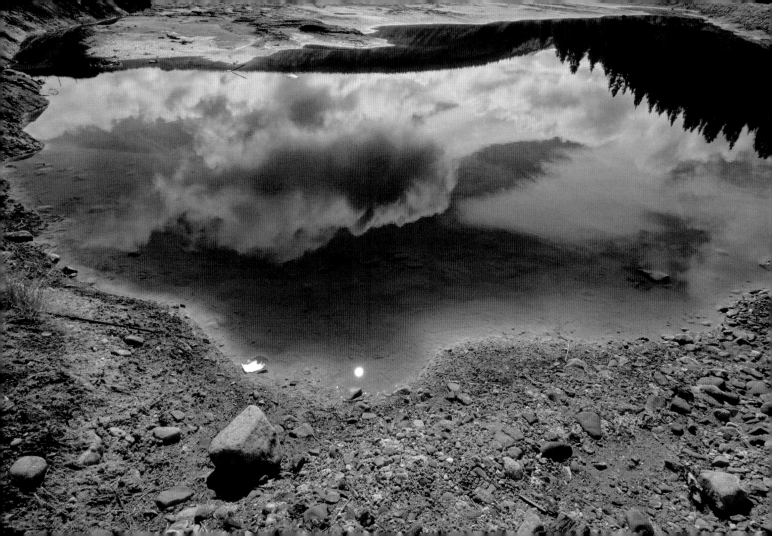

Mining Hard Rocks: Polluting, Royalty-Free

On May 10, 1872, the U.S. Congress approved a legislative bill called the General Mining Act. This act allowed all citizens 18 years or older the right to locate and work a lode (hard rock) mining claim on federal lands. The price of the land patent was $5.00 per acre. Remarkably, this law was still in effect when I did a story in 2000 about the environmental legacy of the law. Even more remarkable is that it is still the law of the land today.

There have been a few laws added that put some environmental regulations in place, and there has been a moratorium on new mining patents since 1994. However, from 1872 to 1993, mining companies took more than $230 billion worth of minerals out of federal land, according to the Mineral Policy Center. While companies that fund coal, oil, and gas exploration on public lands have been paying royalties to the federal government for many years, there are no royalties paid on any minerals found.

In the western United States, mining is a way of life in some rural communities. It is part of that American psyche where the belief is strong that the government should give every person the right to work the land with as few restrictions as possible. I photographed a few individual miners who scraped out a living on their mining claim with a burro and a pick. However, large corporations do most of the real mining; they dig open pits and use cyanide to leach the gold out of huge mounds of ground-up ore. The boom-and-bust nature of mining is such that when the ore starts to run out, the companies often shut down, pack up, and leave, and the taxpayer gets the large bill for the cleanup.

When I covered this story, gold mining was booming in northern Nevada. There were several large open-pit mining companies near Winnemucca. This was the first story that I worked on for *National Geographic* where most of the people I contacted turned down my request to photograph them. Until that point, my association with the *Geographic* had almost always opened the doors wide open. Sometimes people could even be too accommodating, and make it hard to work with natural situations. But the miners must have thought that I was a crazy environmentalist, or perhaps they just didn't want a journalist to see what they were doing. In any event, I got turned down so much that I developed a personal policy to take an aerial photo of any mine that wouldn't give me access. Even a recalcitrant mine operator doesn't control the air space above the mine. Eventually, a few of the smaller mines let me take photographs, but I took a lot of aerials. I learned that those aerial shots were often the best way to show the environmental impact of the large mines.

At the time of the story, there were 30 hard rock mining and mineral processing sites in the West that were on the EPA's Superfund list. This photo was taken in the California Gulch Superfund Site in Leadville, Colorado. In the late 19th century, Leadville was booming. For almost 100 years, millions of ounces of gold and silver were recovered from mines surrounding the city. But eventually the ore ran out, and the soil and surface water in the mining district were heavily contaminated with lead, zinc and other heavy metals. After several decades of cleanup, there is now a 12.5-mile Mineral Belt Trail that passes through the Superfund site and gives visitors a glimpse of the history and scars of hard rock mining in the American West.

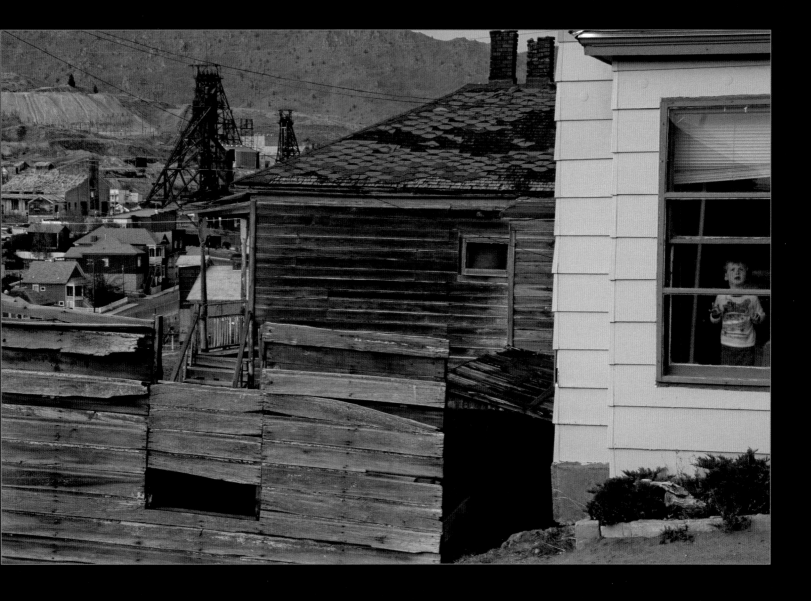

Butte, Montana: Long After the Boom Went Bust

One afternoon in Butte, Montana, I saw a young boy looking out a window against a backdrop of old mines and dilapidated homes. It seemed to illustrate quite a bit of symbolism regarding the history of hard rock mining, so I took a few frames and continued walking.

The more I thought about it, the more I realized that Butte was a good example of why we need economies built around sustainable development. We tend to think of environmental stories as depictions of pollution of the water, land, and sky. Certainly Butte has plenty of all three. In the region around Butte, there are scores of abandoned mines with toxic tailings that cause particulate air pollution, and there is a mined-out, open pit that is now filled with polluted groundwater.

However, there is also the story of how dependence on a non-renewable resource causes a boom and bust economy that can be harmful to the community that depends on it for employment. From the late 19th century until the present, Butte has gone through all the cycles associated with an economy based on mining. Butte started as a mining camp and grew into a boomtown that, in 1920, had a population of 60,000, making it one of the largest towns west of the Mississippi. The mines were right in the town, and Butte's nickname was "the richest hill on Earth." The town was known for its rough-and-tumble individualism. There was a large saloon and a red light district. The famous Dumas Brothel operated legally in Butte from 1890 to 1982.

In the 1950s, Anaconda Cooper switched from underground mining and started excavation of the Berkeley Pit. Thousands of homes were destroyed in order to dig the huge, open pit copper mine, which was the largest of its kind in the United States at the time. When operations in the pit and surrounding mines were shut down in 1982, the water pumps that had been keeping out the groundwater were also turned off. The pit filled with groundwater that was highly acidic and laced with heavy metals, making it toxic to humans and migratory birds. In one incident, 342 migrating geese died when they landed in the lake. This resulted in loudspeakers being installed to scare off wildlife.

Eventually, the town's economy switched to historic preservation and environmental cleanup. With miles of contaminated waterways nearby, along with four open pits, the Silver Bow Creek/Butte Area Superfund Site is one of the largest in the United States. The third five-year review report was signed in 2011, and the list of remediation procedures is mind-boggling. The work has included soil stabilization and removal of thousands of cubic yards of contaminated soil, construction of many treatment ponds, and expensive biological monitoring.

In an ironic twist, the Berkeley Pit is now one of the most popular tourist attractions in Butte. For a $2 admission to the viewing platform, one can see the one-mile-long, 1,780-foot-deep pit filled with heavily acidic (2.5pH) water that is 900 feet deep. There is also a gift shop nearby.

My best motivation to do environmental stories is when I see children like the boy looking out the window in Butte and wonder about the world we are leaving for them.

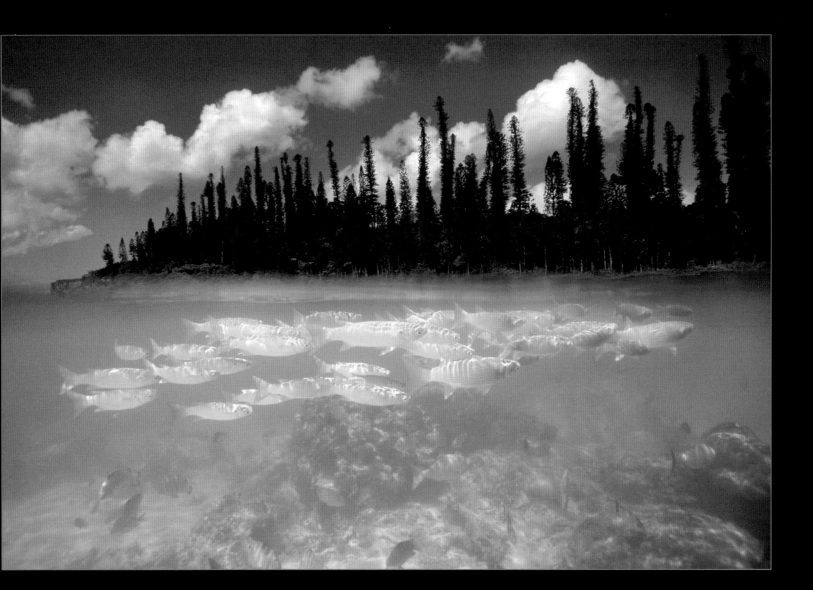

New Caledonia: Endemic Plants and Nickel Mining

The French territory of New Caledonia is the kind of place I probably would never have visited were it not for a *National Geographic* assignment. Actually, few Americans go there as tourists, and many Americans have never even heard of the place nor could they tell you where it's located. I admit I had to look it up on a map when I got the assignment to see exactly where it was out in the vast Pacific Ocean.

For some unknown reason, the French have held on to New Caledonia as a colony. It is more accurately referred to as a special collectivity of France, which sets it apart from other French territories like Guadeloupe, Martinique, or the Réunion Islands. This status was the result of the 1998 Nouméa Accord, which established a special New Caledonian citizenship for the residents and a gradual transfer of political power to the original population over a period of 20 years.

New Caledonia has many ecological charms, such as coral gardens in the surrounding turquoise seas and rainforests along steep mountain slopes. It is a dream destination for botanists. There are 3,400 native plant species, three-quarters of which are endemic, found only on New Caledonia. One species, *Amborella trichopoda*, may be the closest living relative to the first flowering plant that evolved 135 million years ago. Compared to all the other islands in the world, only Hawaii, New Zealand, and Madagascar have a higher number of endemic flowering plant species.

The reason for this biological diversity is that the island of Grand Terre, the main island in the New Caledonia archipelago, is very old; it broke off from the greater mainland of Australia 80 million years ago. The island has descendants of plants that date back to the age of the dinosaurs.

Another contributing factor to the high species count is the fact that many areas of Grand Terre are covered by a magnesium-and-nickel enriched soil called ultramafic. Many plants had to evolve in order to survive in this highly toxic environment. The nickel miners prize this rust-colored soil; nickel mining is one of the main economic industries on the island, but one that has a high environmental impact. Organizations such as Conservation International and the World Wildlife Fund have identified New Caledonia as a global hot spot because of the threat mining poses to the high level of biological diversity. I was able to travel around the island in a rented Land Rover to witness firsthand the incredible vegetation in the tropical wet and dry forests, as well as scars from past and present nickel mines.

On the Isle of Pines, a small island near Grande Terre, I found a beautiful lagoon with tall araucaria trees around the rim. I used an underwater housing with a split diopter filter to photograph a school of mullet swimming past the primitive-looking trees. I'd left my camera gear on a rock as I walked around the lagoon taking photos, and when I returned a couple of hours later, I found that the tide had risen and soaked all of my equipment with the brackish water. I panicked at the thought of losing all my cameras on the second day of the assignment. Fortunately or unfortunately, this had happened to me before and I'd learned from experience to rinse the equipment in fresh water and dry it out slowly. In the small capital town of Nouméa there was a highly trained camera repairman who was able to salvage almost all of my equipment.

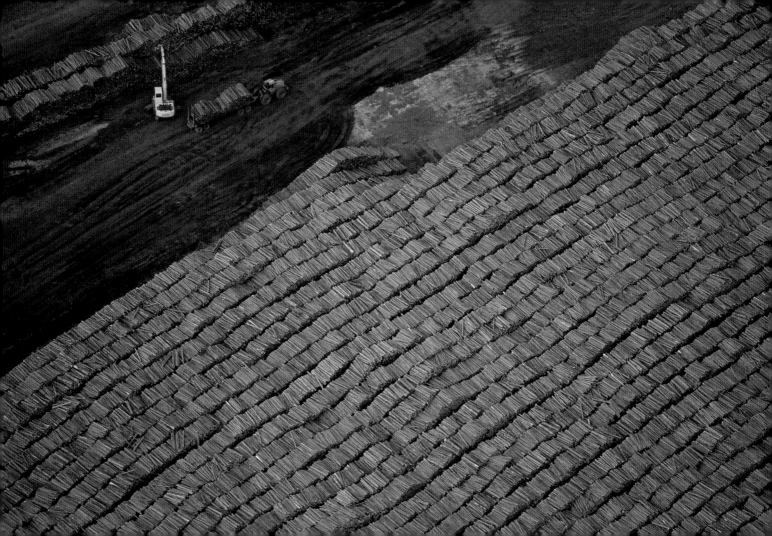

The Boreal: A Great Forest Under Threat

The boreal forest is often referred to as Earth's Green Crown. Tucked between the tundra to the north and the temperate zones to the south, the boreal region stretches across central Alaska, Canada, Scandinavia, and a huge swath of Siberian Russia. I jumped at the chance to do a story about these beautiful forest landscapes and contemporary environmental issues.

For the coverage, I wanted to photograph the boreal forest in every season. Winter in Russia sounded like great material, so I flew to St. Petersburg in April of 1999 for a six-week trip. My guide, Max, and I hired a driver and headed north towards the forests of Karelia. The first day's drive ended when we had a flat tire somewhere that I couldn't find on my map. On the third day, we arrived at a Russian Strict Nature Preserve near the Finnish border.

The preserves are usually reserved for scientists and are not open to the public. Max was able to negotiate access and persuade a ranger to stay with us at a guesthouse in the preserve. I took many pictures during our stay, the best being one of a solitary man walking by in a snowstorm after being caught fishing illegally. Each night after photographing, the three of us would go into a sauna behind the house. After about a half an hour of sweating, Max and the ranger would jump out and roll around in the snow as I watched in disbelief.

In the Ural Mountains, we had to hire a Russian helicopter to fly into a remote valley in the Komi National Park. We planned to stay in a lodge for three days and then have the helicopter return for us. On the third day, there was a blinding snowstorm, but the helicopter arrived anyway. During the flight out, Max panicked when he realized the pilot was flying almost blind. Fortunately, we landed safely and continued on our trip.

Next, I set out for Canada and Alaska in mid-summer. The distances are great, but I didn't have to deal with the big language and cultural divides that I faced in Russia. Near Winnipeg in Manitoba, I took an aerial photo of a log yard of old-growth trees from the boreal forest. I later learned that the timber was being turned into pulp to make newsprint, a sad irony for me as a photojournalist.

I timed my trip to Sweden in the fall to photograph the autumn colors. The tree species of pine, spruce, and birch are all remarkably similar in the boreal forests around the globe. The deciduous birch trees' leaves turn golden-yellow in the fall, and I found some nice colors at Färnebofjärden National Park on the southern edge of the boreal. In Swedish Lapland, I was driving down a remote dirt road when all of the sudden a large group of reindeer appeared and crossed the road. A Sami man was herding several hundred through the forest. Then, right in front of me, two of the reindeer started locking their horns. The males were so engrossed in their fight for mating rights that I was able to photograph them closely for several minutes.

Scientists now know that the boreal forest plays a key role in the future of climate change. Huge amounts of carbon and methane are locked up in the bogs and permafrost. If these greenhouse gases are released by global warming, the consequences are frightening.

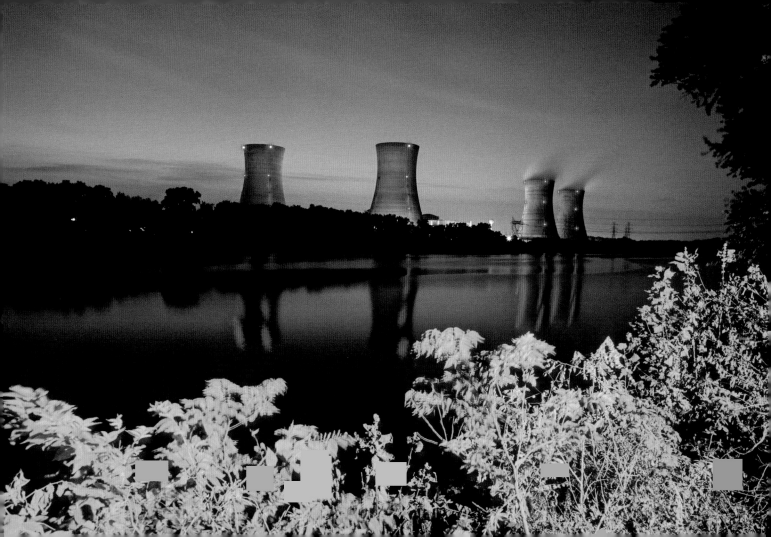

Three Mile Island: Where Nuclear Hopes Melted Down

Before TMI stood for "too much information," these were the initials of the location of America's worst accident at a commercial nuclear power plant. Three Mile Island has become such an icon of the environmental movement it is sometimes hard to realize that Three Mile Island actually is a place, an island on the Susquehanna River in Pennsylvania.

At 4 a.m. on March 28, 1979, there was a partial meltdown in the TMI-2 reactor. The cause was a stuck valve that allowed coolant to escape, and a plant operator overrode the automatic emergency cooling system by mistake. It took five days for the scope and complexity of the accident to become known. There was a voluntary evacuation of pregnant women and preschool-aged children within a 20-mile radius of the plant.

It was eventually determined that small amounts of radio-active gases and iodine were released into the environment during the meltdown, but not enough to warrant concern. A presidential commission did an investigation, but it was not until much later that the public learned the full details of the accident. The commission strongly criticized Babcock and Wilcox, the maker of the reactor, and the energy company, Met Ed, for inadequate operator training, poor management, and inadequate safety procedures. The cleanup started in August of 1979 and officially ended in December of 1993. It cost a total of a billion dollars.

The high cost of construction and the fear of another accident like what happened at TMI are often cited as reasons why there have been no new nuclear reactors built since 1979. The accident happened just 12 days after the release of the Hollywood movie *The China Syndrome,* a fictional account of a major nuclear crisis starring Jane Fonda. TMI and the far-worse Chernobyl meltdown in 1986 resulted in an increase in the "no nukes" activism that continues to this day.

So what should an environmentalist think about nuclear power? The overall safety record of the industry is very good and the amount of power that a nuclear plant can produce is unmatched. The situation with climate change is so critical that some well-respected environmentalists and researchers believe that we must increase the use of nuclear power in order to reduce greenhouse gases and to replace coal-based electricity. I understand this reasoning, but it seems to me that the high cost of nuclear power, along with the problems associated with the waste, do not make it the best energy source for the future.

When I visited Three Mile Island in 2001, the company officials refused me permission to photograph on site. I was able to do some aerial photos, and I found a spot on the shore next to a beacon for boat traffic where I could set up for a dusk photo. I anticipated the glow of the lights on the cooling towers and the steam coming from the still operational TMI-1, but it wasn't until I saw the film that I realized the green cast of the beacon was so apparent.

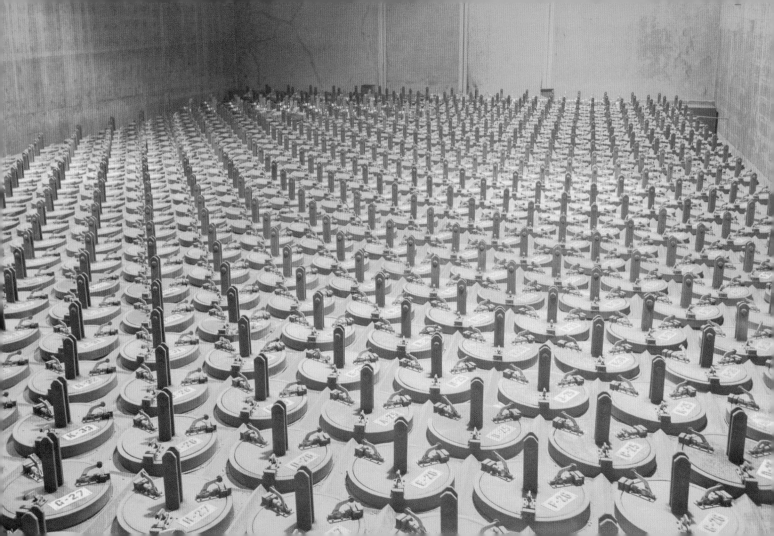

Photographing the Infinity Room: Timing is Everything

Nuclear power is a divisive issue because it holds so much potential for both energy and harm. One of the key environmental issues is how to dispose of waste from nuclear power and from the production of warheads, which can remain toxic for millions of years.

There are over 100 nuclear plants in the U.S., and they are all currently storing their waste on site. The waste is in the form of highly radioactive spent fuel rods and is an obvious security risk. Most of the plants store the waste in pools about 30 feet deep, but some use large canisters that sit in fenced-in lots near the plant.

However, the real story with nuclear waste in the U.S. is the huge amount left over from the Cold War era when America built over 70,000 nuclear warheads. It is hard to imagine why any country would need so many when just a few could wipe us all out, but that was what the U.S. did in an effort to keep up with or surpass the Russians and their equally aggressive nuclear program. At the end of the Cold War in 1989, it became apparent that all these weapons were not needed. Efforts were shifted to dismantling the weapons (very carefully) and to disposing of the waste. Many workers who once secretly built weapons were now tasked with the not-so-glamorous job of cleaning up the mess.

And what a big mess it is! For instance, in the early years at the Hanford Nuclear Facility in Washington, the waste was just buried in single-walled containers. That waste is now slowly leaking into the groundwater. There are efforts to monitor the movement of the waste, but there are no plans to clean it up due to the high cost and the possibility that disturbing the waste may make things even worse. There is also lower-level waste at several facilities, which is easier to deal with, even though the volume is greater. Low-level waste is loaded in large barrels and either buried on site or shipped to an underground salt mine in New Mexico and entombed there.

In order to get access to photograph at these formerly secret facilities, I had to go through a lot of red tape. Fortunately for my project, the facilities were eager to show off their cleanup activities. While I was at the facilities, I was able to photograph some of the largest amounts of radioactive waste found anywhere in the world. One example is this photo of a dry storage area, called the Infinity Room, at INEEL, the Idaho Nuclear Engineering and Environmental Laboratory. The waste in each of those canisters will be toxic for millions of years. It was once thought that this type of waste could be shipped to the Yucca Mountain repository in Nevada, but now that will most likely not happen anytime in the near future. Even though Congress approved the storage site in 2002, in 2011 Congress voted to terminate funding for the project. The U.S. Government Accountability Office stated that the reason for the change was political maneuvering and not any safety or technical issues.

It turned out that the summer of 2001 was the perfect window in time to do a story on nuclear waste. As fate would have it, I finished my last picture on the nuclear waste story on September 8, 2001, just three days before the terrorist attacks on The World Trade Center and the Pentagon. After 9/11, allowing visitor access to places like nuclear waste sites was deemed too risky because of the new war on terrorism. And in the years before, these facilities didn't officially exist. I didn't realize it while doing the story, but timing was on my side and I was able to document a legacy of the Cold War that will last almost forever.

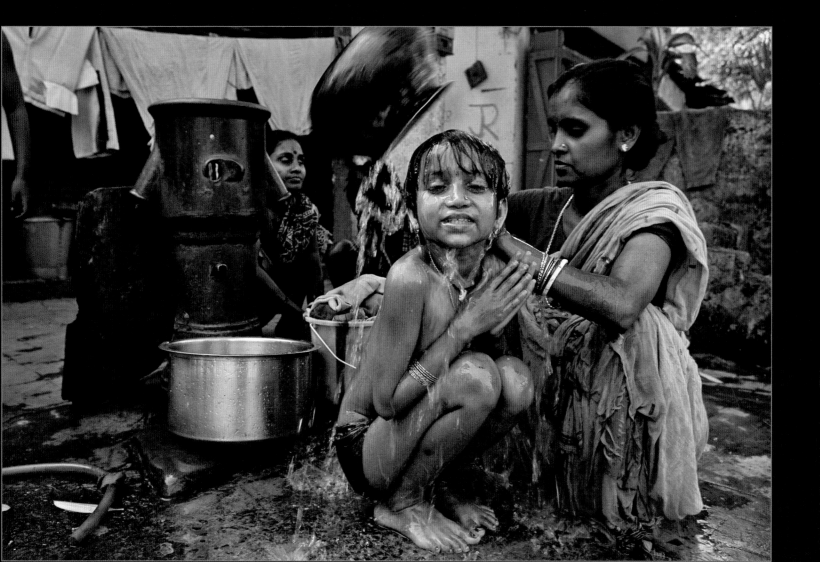

Global Freshwater: Not Enough to Go Around

Working on the special water issue for *National Geographic* in 1992 was an eye-opening experience. This was my first attempt at covering a major, important environmental issue. However, I realized that water issues in North America were only part of the story. There were problems with water supply and pollution in North America, but they were minor in comparison to much greater concerns in other parts of the world.

In 1992, most of the magazine's subscribers lived in the United States. By 2004, there were several international editions of the magazine, so the stories started to take on a more global feel in order to meet the needs of the new readers. This gave me the opportunity to do an environmental story on a much larger scale.

In doing research on freshwater quality and quantity around the world, I found some astounding statistics: over one billion people on the planet don't have access to clean drinking water and two billion people don't have access to proper sanitation. Agriculture uses 70 percent of freshwater, while 20 percent goes to industry, and domestic use gets the rest. Only 10 to 20 percent of rural Ethiopians have access to clean drinking water, the lowest figure in the world. Jordan has one of the lowest per capita rates of water usage in the world. I discovered that the water would run in taps to homes on the West Bank only once a week. Most of the homes in Jordan installed tanks on their roofs in order to have enough running water make it through the week.

In the Middle Eastern country of the United Arab Emirates, the political realities of water have come into stark focus. The country has almost no surface freshwater, but because they have an abundance of oil they can produce drinking water from the sea using expensive desalination techniques. The result is a Vegas-like atmosphere in Dubai, with water parks and fountains in the desert. In the south, they are mining million-year-old groundwater to grow tomatoes. The tomatoes grow well in the desert, at least until the water runs out.

But the question became, how could I make beautiful pictures to illustrate these facts?

India turned out to be the country where I was able to illustrate many of the most pressing global issues. In Calcutta, where this image was shot, most homes in the city had a tube well, so adults would bathe children on the street corner without any concern for a passing photographer. Nearby in West Bengal, the wells are contaminated with natural arsenic, causing a host of health problems for those who depend on the wells for survival. In New Delhi, a city water pipe passed right over a group of squatters. The tap water was headed for the people in the city who could afford clean water in their homes, but the infrastructure was old, so the leaks did provide at least some water for the poor people living under the pipe.

In the north of India in the foothills of the Himalayas, I photographed the large Tehri Dam as it was being built. The pipes to feed the turbines were gigantic. Displaced people who had lost their homes in the rising waters behind the dam were protesting. The water wars had moved to India. In all likelihood, these wars will continue and become more urgent around the world, as many countries face a scarcity of the freshwater necessary for survival and a productive way of life.

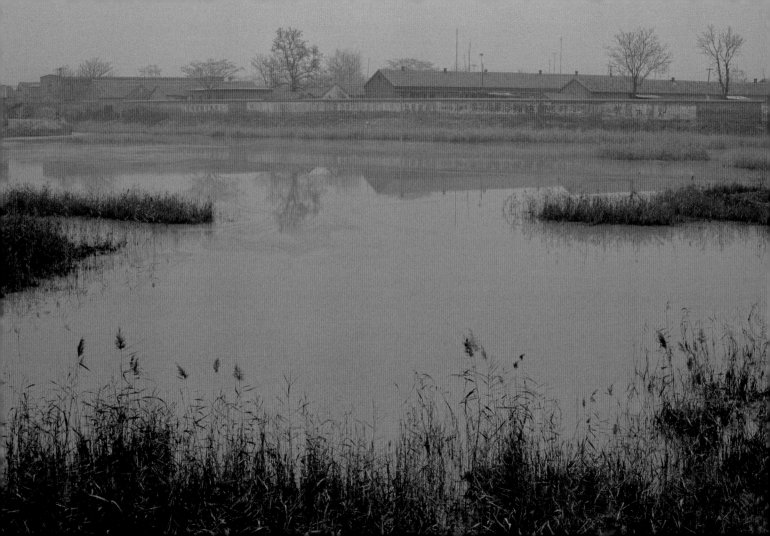

Pink Waters: Along the Yellow River

It is difficult—probably by design—for a Westerner to get reliable information about pollution in China. Certainly, it is obvious to any visitor that China has a problem with air and water pollution. They seem to have adopted the same method of development that all the other industrialized countries followed: grow fast now and clean up later.

One of the statistics published by China's own Ministry of Environmental Protection is that as many as 750,000 people annually die prematurely in China from respiratory disease related to air pollution. Beijing now has only the second worst air pollution in the world after New Delhi; the air is frightfully bad as a result of industry and burning coal for power.

The situation with water pollution in China is just as bad as the situation with the air. An estimated 980 million of China's 1.3 billion people drink polluted water every day. More than 600 million Chinese drink water contaminated with waste and 20 million people drink well water contaminated with high levels of radiation. China's high rates of liver, stomach, and esophageal cancer have been linked to the water pollution.

These statistics are probably just estimates, at best. Most water treatment plants in China lack the facilities to test their water for all pollutants, and there are few independent water quality testing companies. In any case, most people in Beijing don't drink the tap water and haven't for many years.

It is also hard for an environmental journalist to get an accurate picture of water pollution in China. In 2002, I was working on a story about freshwater issues around the world and I read about the conditions along the Yellow River. In some years, the river that is known as China's mother river wasn't even making it to the sea because so much water was being extracted for agriculture. Also, there were 4,000 petrochemical plants along the watershed, most of which discharged waste directly into the river.

At the time, the only way for a foreign journalist to work in China was to go through the government organization of "minders" tasked with showing us the parts of the country that were open to foreigners. It is easy to see how hard it was to get pictures that accurately represented the conditions. For my five-day trip along the Yellow River, I had to meet with a whole series of local bureaucrats in order to get permission to photograph. This usually meant a long luncheon with a Lazy Susan full of food, lots of alcohol and toasts to Americans, but little time for photography. Driving to one of those luncheons, I spotted this small lagoon with pink water near the Yellow River. I asked about it, and was told the pink was a preservative discharged from a tofu plant, but that we didn't have permission to photograph there.

After a long luncheon that went into the afternoon, I waited until everyone had had a lot to drink and I snuck out. I waited till dusk and took my photos, and then went back to the party and wasn't missed at all. Thankfully, in recent years it has become possible to hire an independent "fixer" to travel around the country for photo articles. Not only do you get a more accurate view of the story, but a photographer can also spend more time taking photos rather than going to luncheons and giving toasts to Americans.

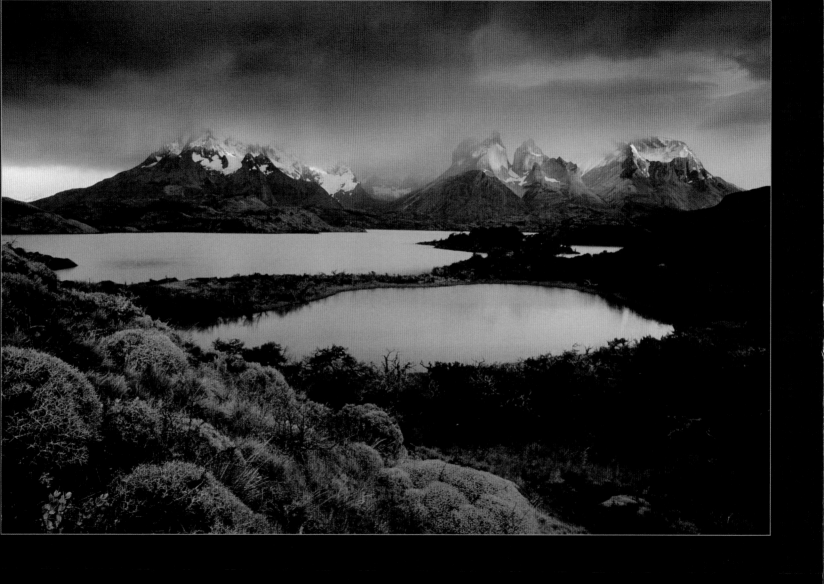

The Most Beautiful Place in the World: IMHO

I am often asked if I have a favorite destination of all the places I have visited. I have been to all 50 of the United States, and to over 100 countries and territories around the world. But that doesn't make it any easier to pick a favorite place.

When people ask me that question, I often think they are looking for an interesting place to visit. Everyone seems to like to travel, but people like to travel for different reasons. Some want a vacation getaway from the stresses of work, with a nice beach to rest on or a cruise ship where they can be pampered. Others like a cultural experience, to go to a festival, or to try to hang out with the locals. Many people like to try the local cuisine. All these things influence their choice of which locations they wish to visit. A few enjoy seeing remote, beautiful places, but still want to travel with reasonable comfort.

In my work for *National Geographic,* my task is to take beautiful pictures to illustrate a story. The subjects I photograph may be different for each story, but the demand to bring back the publishable photos is the same. Most of the time, getting a unique photograph requires a lot of hard work. I have a saying: if it is easy, it probably has already been done. From a creative standpoint, an easy photograph is usually not very fulfilling. This makes it hard for me to suggest many of the beautiful places that I have visited. Many locations are just too difficult for most people to ever experience because of the time, money, and/or effort required to get there.

However, there is one place I can recommend without reservation: Torres del Paine National Park in Chile, near the tip of South America, in the southern part of Patagonia. Scenic 3,000-foot-high granite cliffs rise above large, pristine freshwater lakes. The light and cloud formations are dramatic and ever changing. It takes a few long plane flights to reach, but the park is accessible for most. It is possible to stay in nearby hotels or in wilderness huts in the park. Believe it or not, this photograph was taken a stone's throw from a five-star hotel, the Explora Patagonia Hotel Salto Chico. It is an amazing hotel, situated next to a waterfall, with big bay windows looking towards the mountains. To stay there, you would probably need a rich uncle, but it may be worth it as a once-in-a-lifetime experience.

Posh hotels aside, Patagonia is a fabulous place to visit. If you are a traveler, I'm sure you would fall in love with this place. Most of Patagonia is a high desert called the puzta. It is very sparsely populated; there are only a few scattered outposts and estancias. The estancias are sheep ranches run by gauchos, the Argentinian version of the Western cowboy. The Andes to the west are fabulous, and to the east, the Atlantic coastline is teeming with wildlife. It is a dream locale for a photographer.

Some like Paris for the ambience, Tuscany for the food, or the Holy Land for a spiritual encounter. But for scenery, Patagonia is hard to beat. In my humble opinion, Torres del Paine National Park—Patagonia's Crown Jewel—is the most beautiful place in the world.

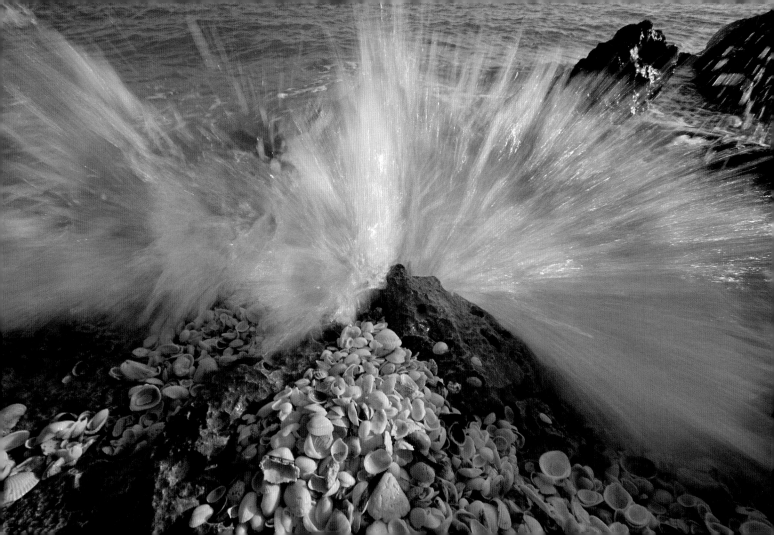

The Carbon Cycle: Reporting on Disturbing News

In its natural state, the carbon cycle is at the heart of life on Earth. When *National Geographic* decided to do a story about climate change, the editors wanted to first publish a story about the carbon cycle. It turned out to be a good decision, because understanding how the cycle works when it is undisturbed makes it far easier to comprehend the current state of global warming.

Carbon will cycle through different ecosystems at different rates. In the tropics, a leaf that falls on the forest floor will decompose and turn back to carbon dioxide within one year. In the boreal forest, a leaf can fall into a fen and take over 500 years to cycle back into a gas. In the longest cycle, rain falling on limestone on a mountain picks up calcium carbonate and deposits it on the ocean bottom. It can take over 200 million years before that carbon returns to the atmosphere via a geothermal vent or volcanic eruption.

Another aspect of the carbon cycle is the role that carbon took in the history of the evolution of life on Earth. It was about 550 million years ago that there was finally enough carbon in the ocean for shells to form. Many scientists believe that these calcium carbonate shells, or exoskeletons, were a major factor that made it possible for multicellular animals to evolve during the Cambrian Explosion. Exoskeletons play a key role in protection from predators, support, and providing an attachment for musculature.

To illustrate this, I went to Sanibel Island in Florida, a good place to shoot pictures of shells. Because of its position on the Gulf of Mexico, lots of shells are washed up on the beach during storms. When I got to Sanibel I discovered that there were lots of shells, but they were too small for an effective photograph. The first evening, I decided to try to dig a hole in the sand where I could place my tripod. This way I could get closer to the shells on the beach and hopefully have a sunset in the background. The picture looked okay, but there was no center of interest, just a flat bunch of similar shells with the horizon behind. Time to start hunting around for a new location.

The next day I found some small rocks with shells lying on and around them. There were small waves breaking on the rocks. The waves were only about a foot tall, and if I got close enough to the shells, they became recognizable. I was able to sit down and hold the camera close to the shells as the waves broke over the rocks. I had to use an underwater housing for my camera, since the waves soaked it after each exposure. The close perspective made the waves seem larger and more powerful than they really were. The exposure that was by far the best had the water almost filling the top half of the frame.

The human body is made up of 18 percent carbon. When we die, that carbon will decompose and cycle back into a gas just like it does with all organic matter. It is the living humans that are disturbing the natural carbon cycle. When we burn coal, which is 92 percent carbon, or oil, which is 86 percent, we significantly increase the amount of carbon in our atmosphere, which is naturally only .015 percent. This increase in greenhouse gases is having profound effects on all aspects of life, as I would soon find out while photographing a major story on climate change.

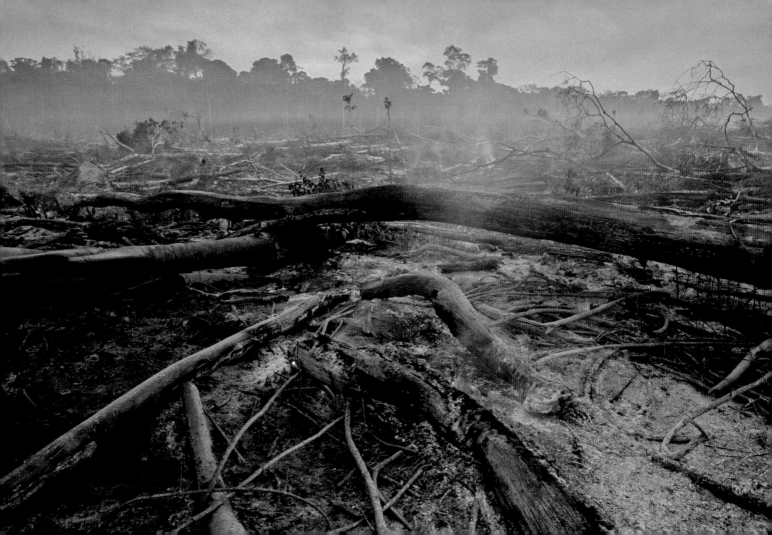

The Amazon: Lungs of the Earth, Burning

Before the advent of human civilization, it is estimated that 50 percent of the Earth's land mass was forested. Today, after 10,000 years of land clearing for farms, factories, and cities, nearly half of that original forest is gone.

The industrial revolution of the past three centuries has put additional stress on the world's forests. All forest types are suffering to some extent by an increase in drought conditions and a rise in pests and diseases that thrive in the warmer climate caused by global warming. The last decade has seen an increasingly rapid increase in record temperatures and forest mortality.

The tropical rainforests occur in a band around the globe within 5 degrees latitude of the equator. Tropical forests are a hotbed for diversity and species evolution. The Amazon is the most amazing rainforest of all. There are 1.6 million known species on Earth and one tenth of them live in the Amazon. These forests are the source of many new and potential discoveries of medicines important to human health.

For a story on the carbon cycle, I photographed some scientists doing research near Manaus, Brazil. The Amazon region is often considered to be the lungs of the Earth because the forest takes in so much carbon dioxide and releases so much oxygen. This carbon sink (i.e., something that absorbs more carbon than it releases) is crucial to the workings of the Earth's atmosphere, but the amount of the exchange is not exactly known. Scientists measure these levels by putting meters in the tree canopies to register how much carbon dioxide is given off by decomposition and how much the trees are absorbing during photosynthesis. The net difference is how much carbon dioxide the forest is eliminating. We need all the help we can get to try to make up for the excess carbon dioxide humans are releasing into the atmosphere with the burning of fossil fuels. In 2010, 9.14 gigatonnes of carbon were released from fossil fuels and cement production worldwide.

However, the problem is even greater because we are releasing the carbon stored in those trees when we cut down the very forests that are helping us. This is called land use change, and in 2010 it contributed an additional 0.87 of carbon gigatonnes into the atmosphere. At the current rate of deforestation, it is estimated that 55 percent of the Amazon rainforest will be converted to farmland by 2030.

After I finished photographing the scientists near Manaus, I drove into the rainforest on a dirt road. Near sunset, I happened upon this large field of downed trees that were still smoldering. Here, another part of the Amazon rainforest was the latest victim of slash-and-burn agriculture. I asked a passerby if they knew what had happened, and they said that a farmer wanted more land. It is hard to know the exact details, but this land will probably be used to grow corn or a similar crop to feed people or make fuel for Brazil's rapidly developing economy. The really sad part is that the soil in the rainforest is very depleted due to the accelerated rate of decomposition, and the land is only productive for a year or two. After that, the beautiful Amazon will be reduced to scrubland, all in the name of progress.

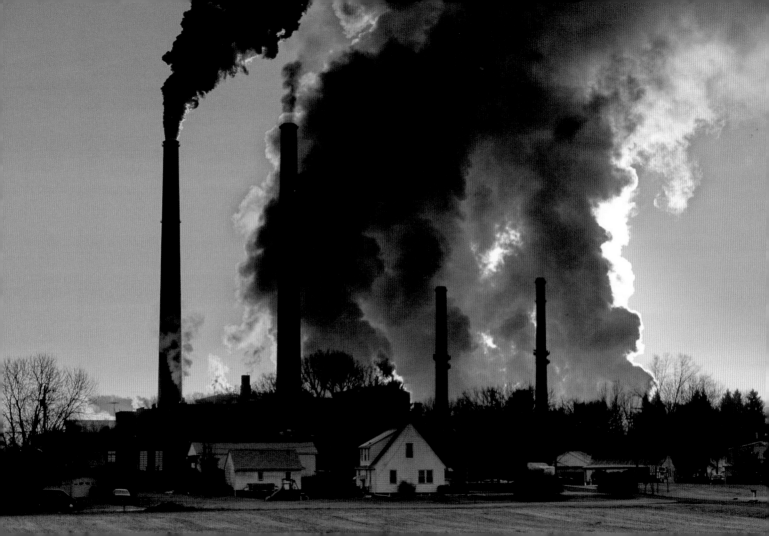

Climate Change: The Atmosphere Doesn't Lie

In 2004, I did a major article about climate change for *National Geographic*. It turned out to be a 74-page cover story that I worked on intensely for one year. During the course of the fieldwork, I talked to and photographed many of the leading scientists in the field. In the years since, I have continued to photograph related topics, and I read all I can on the subject. I don't like the role of doomsayer, but I am not optimistic that we will solve the climate problem in the near future.

If you look at the facts related to global warming, there is no reason to be optimistic. Carbon dioxide levels continue to rise each year by about 3 parts per million. Sophisticated climate models now show that within ten years we will begin to reach levels that allow positive feedback loops, and warming will begin to accelerate exponentially. Also, carbon dioxide stays in the atmosphere for up to a century, making it difficult to solve the problem quickly. It is feasible that if we switch to non-carbon energy sources, this catastrophe for future generations could be avoided. However, all indications point to the fact that it is not politically feasible to stop using coal and oil as energy sources in the near future, and the status quo will continue for years to come.

How can this be? After all, aren't we living in the age of information? Shouldn't it be obvious that carbon is harming the atmosphere, and the only solution is to stop using it? I believe that we humans are programmed to think in the near-term. We are really good at solving problems that confront us on a daily basis. For example, when a town experiences a tornado or a flood, usually the community rallies together along with outside help to rebuild. But when the problem is one that slowly builds over a century or more, our natural instinct is to put it on the back burner.

I am quite sure that the truth about the seriousness of climate change will eventually be regarded as fact. The public will believe only so much deception by naysayers. However, we are running out of time to change before serious impacts occur. Climate scientist Lonnie Thompson has said that he believes the public won't change their outlook based on the data alone. He believes we will only change after enough storms or extreme weather events are so devastating that we have to take notice, even if our actions come later than they should.

It doesn't make me feel good to raise my voice with bad news, but it doesn't feel right to ignore climate change, either. This photo is of a coal-burning power plant in Conesville, Ohio.

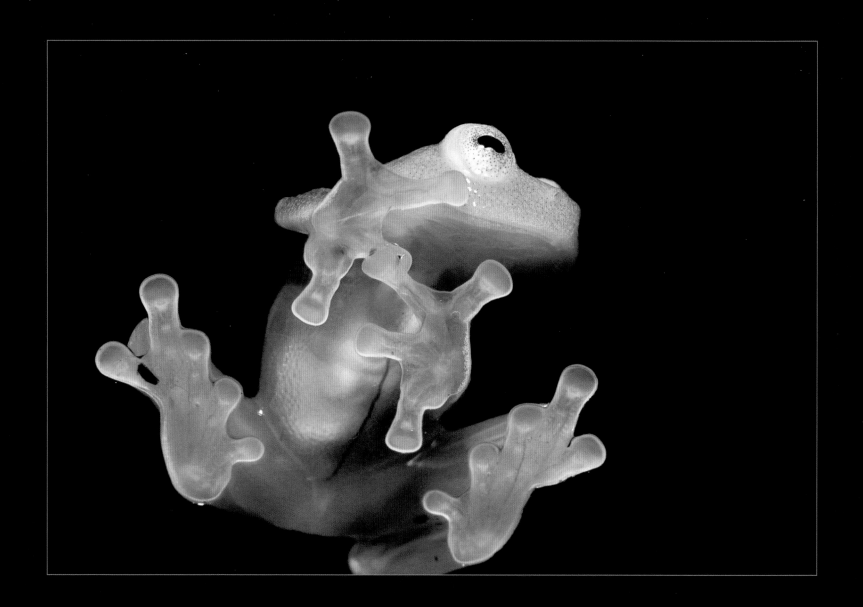

Climate Change: Bugs Like it Better than Frogs

A large portion of the article I photographed on climate change dealt with ecological changes. It was called "No Room to Run." The most obvious results of climate change are the physical ones—retreating glaciers, thinning sea ice, and melting permafrost, to state a few. These physical changes cause ecological ones.

When one starts to examine the effects of warming the atmosphere, all sorts of problems become apparent. For example, migrating animals such as the Porcupine caribou leave Canada each year about a month before they want to arrive at their birthing grounds in northern Alaska. They like to get there before the bugs hatch, when there is enough plant life for their young to forage on. With spring coming earlier, the caribou have been arriving too late and their numbers have been declining. In southern Alaska, the spruce bark beetle thrived in the warmer weather and killed over four million acres of spruce. One thing I discovered while photographing the ecological part of the story is that many animals are having problems adapting to warmer climates, but the bugs love it. The warmer it is, the more eggs hatch, and the more insects thrive.

The other species that are at risk are the ones that grow or live at the highest elevations. Some plants can gradually move up slope and some animals can move up the hill to a colder spot. But this is impossible for animals such as the pika (small, rodent-like mammals) that already live on the highest talus slopes and have adapted to eating certain grasses near their nests. They love the cold and have nowhere to go. It is predicted that these will be the first mammals to face extinction as a result of global warming.

In Mexico, I photographed monarch butterflies, which spend the winter in the cool but relatively mild high elevation forests west of Mexico City. It is quite a sight to see all the trees covered with sleeping butterflies. They gradually wake up as the sun rises. It is predicted that in a hundred years, this region will be too warm and have weather that is too extreme to provide a safe haven for the butterflies. Their numbers will most likely decline dramatically because it will be very difficult for them to change a migration pattern that has become instinctive over thousands of years.

Frogs are facing problems because a fungus called chytridiomycosis, which is lethal to them, becomes more active in warmer climates. The fungus has been proposed as a contributing factor in the global decline of 30 percent of the world's amphibian populations. A decline in frog populations has been documented in Costa Rica. In 1980, in a study of the Fleischmann's glass frog, 300 frogs were counted in a 120-meter stretch of the Rio Guacima. In a repeat survey ten years later, there were, at most, only eight frogs found in the same area. When I met the scientist who conducted the study, he told me that I wouldn't be able to see any frogs at that point in the dry season. However, I was told there were some Fleischmann's glass frogs in terrariums at a place called the Frog Pond in Monteverde. It wasn't what I had originally envisioned, but I started to think that maybe I could photograph a glass frog on a piece of glass. I walked into the Frog Pond carrying my 180 mm macro lens with a flash, and saw one Fleischmann's frog clinging to the side of a terrarium. I snapped one frame and the frog jumped away. I spent the next several hours trying to place a frog in various positions on a piece of glass I had brought, but the initial frame turned out to be the best.

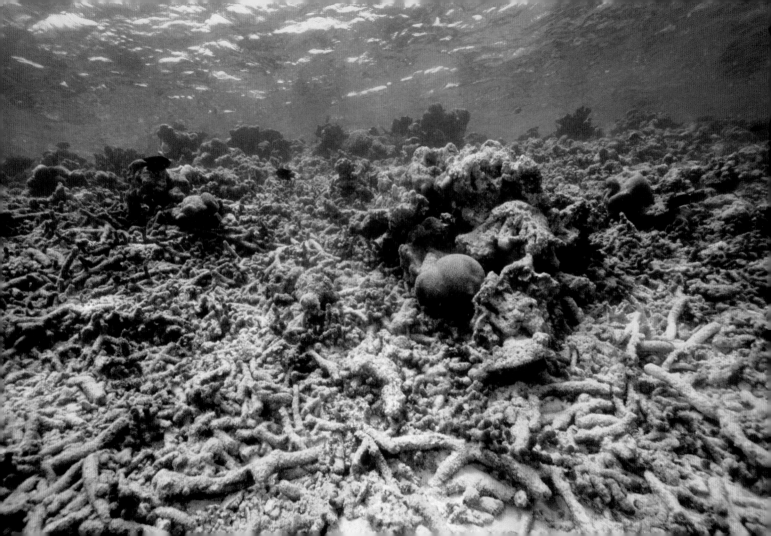

The Maldives: A Coral Paradise Slipping Away

"One of the last unspoiled places on Earth, known as the *flower of the Indies,* has palm-fringed islands, sparkling white beaches, turquoise lagoons, and coral reefs teeming with brilliantly colored fish. It is a unique tropical paradise offering some of the most spectacular dive sites in the world. The largest atoll in the world, Maldives is a garland of emerald islands stretching like a necklace of gems on a vast aquamarine canvas. This is your destination!"

This is how one tourist brochure described this unique country in the Indian Ocean. The Maldives is indeed a spectacular location, and if I were running a tourist resort or dive shop there, I would probably advertise it the same way. However, I had also heard that the coral reefs around the Maldives were suffering from bleaching as a result of increased ocean temperatures. When I arrived on one of the outlying islands and asked the owner of a dive shop if he could show me some of the reefs that were suffering from coral bleaching, he was not too eager to oblige. Although he knew global warming was a threat to the coral, he didn't want to threaten his own diving enterprise. In the end, he showed me where to find the damaged coral if I promised not to divulge the exact location in the Maldives where I took the photograph.

The Maldives archipelago sits atop a vast submarine mountain range in the Indian Ocean. There are 1,192 coral islands grouped in a double chain of 26 atolls. The atolls are composed of sand bars and living coral reefs, which formed around an underwater volcano over a period of 30 million years. The coral are small animals, or polyps, inside a calcium carbonate shell. These coral have a symbiotic relationship with zooxanthellae—single-celled plants that live within the tissues of polyps and provide organic nutrients. Reef-building corals are more like plants than animals in that they grow using photosynthesis. Coral can utilize sunlight in water depths up to 150 feet. Coral reefs provide habitats for a large diversity of marine organisms, help protect coastlines from erosion, and are a big draw for tourism.

Rising ocean temperatures are threatening coral reefs all around the world. In 1998, a warming of as much as 9 degrees F due to a single El Niño-related event in the Maldives caused coral bleaching that killed two-thirds of the nation's coral reefs. Bleaching occurs when the coral under stress push out the symbiotic organisms that contain the colorful pigments. Many of the reefs around the Maldives have re-grown, but the coral can only tolerate so much heat. It is predicted that by the 2030s, 90 % of reefs worldwide will be at risk from both human activities and climate change, and by 2050, all coral reefs will be in danger.

The highest elevation in the Maldives is less than 8 feet above sea level; the lowest of any country on Earth. Given that sea levels have risen 8 inches over the last century and further rising is likely, the Maldives is on the front lines as it faces the negative effects from rising sea levels and extreme weather events caused by global warming. In 2008, as a precautionary move, the former president of the Maldives announced plans to look into purchasing new land in India, Sri Lanka, and Australia because of concerns that the rising sea would eventually inundate the country, making it necessary to relocate the population.

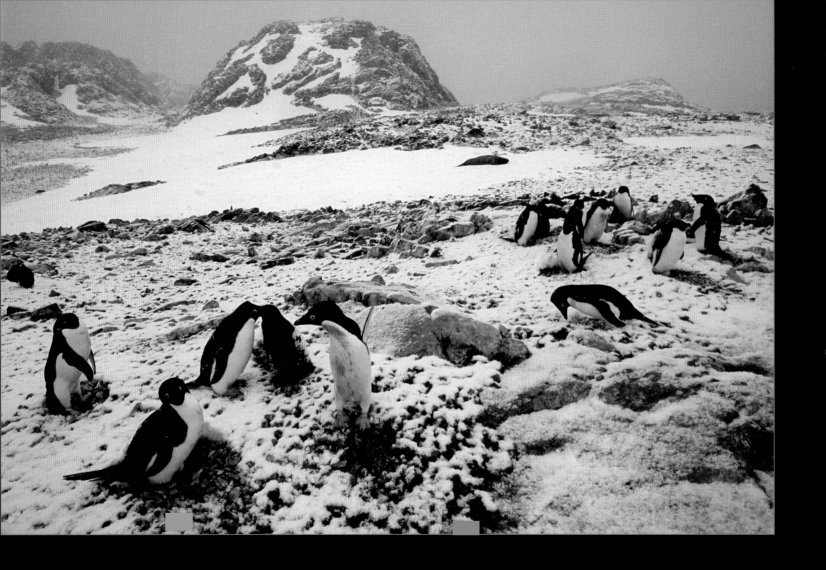

Adélie Penguins: A Boat Ride to Remember

In Antarctica, global warming is having profound effects. We hear news reports of retreating glaciers and ice shelves the size of Rhode Island breaking off into the ocean. All signs point to the ice melting more rapidly than previously predicted, even though it is difficult to get exact figures in this remote part of the world.

At the Palmer Research Station on the Antarctic Peninsula, American researcher Bill Fraser has spent 30 years studying the effects of the warming climate on the Adélie penguins. This region has been more affected by climate change than almost anywhere else in the world. Warming in this part of the world has sped up the water cycle and caused an increase in snowfall. Since Adélies need to nest on rocky, snow-free land, the increase in snow has caused the number of breeding pairs to drop sharply over the last 30 years. Also, there is now little sea ice, which is needed to support the Adélies's diet of krill. Some Adélies seem to have adapted by moving farther south, but recent research has shown that overall populations of Adélie penguins are declining by more than 2.9 percent a year.

The scientists and researchers usually arrive at Palmer Station via an icebreaker in November, and they stay the whole summer before the ship comes back to pick them up in autumn. Since I just needed one shot of Fraser for the article on climate change, I could only afford to spend 3–4 days photographing his work. I looked into flying from Argentina to Palmer Station, but the closest thing to an airstrip is a flat area atop the glacier next to the station that a plane could land on, which would be used only if it were necessary to make an emergency evacuation.

My only hope of getting to Palmer Station was to hire a yacht for a five-day sail across the Drake Passage to Antarctica. I contacted a Swiss man with a 37-foot yacht based in Ushuaia who said he could do the job, but for an expensive fee. I agreed, but when I saw the yacht, it seemed pretty small. There was room for five to sleep, but it wasn't possible to stand up in the cabin below the deck.

The first day, the sail through the Beagle Channel to Cape Horn was beautiful; but when we hit the open sea, the situation turned much more unpleasant. The swells were large, and it was hard not to feel sick inside the cabin. The skipper sat near the control, drank excessive quantities of alcohol, and told us not to worry. I had to force myself to keep going out for fresh air, even though there was nothing to see or photograph. There was an Italian couple that was also on the trip, and they both became very seasick. After the first day, I didn't see them at all until we got to Palmer Station.

Everything got better when we got to Antarctica and I started to photograph Fraser's work. But on the third day of the return trip back across the Drake Passage, we hit a large storm with 20-foot swells. The yacht swayed back and forth, and large waves splashed up on the deck. The Italian couple disappeared to their cabin again, and the skipper just kept drinking. All I could do was marvel that the yacht made it back to Argentina without incident. It was a boat ride I won't ever forget, and one I hope I never have to repeat.

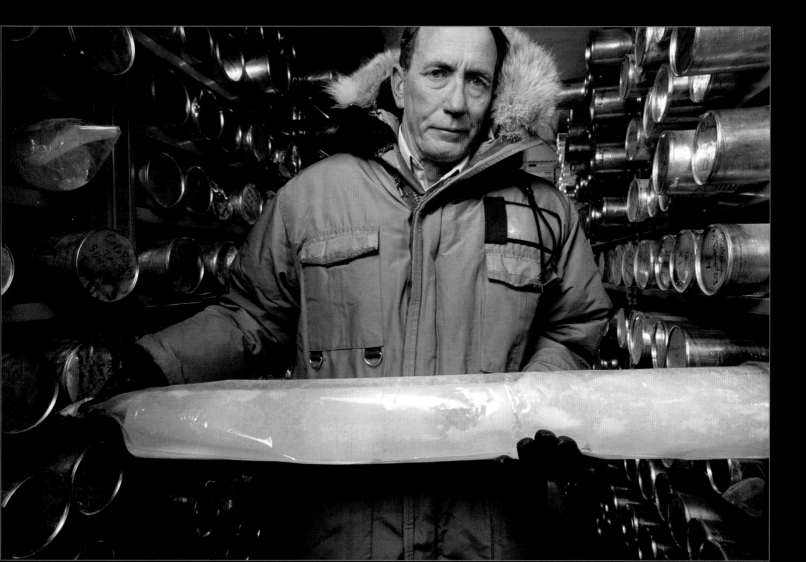

Climate Scientists: Our Modern-Day Prophets

The final segment of the climate change story was called *Now What?* The idea was to look at scientific research that was being done to predict what might happen in the future. The obvious way to do this was to input temperature data from locations around the world into computer models that would project future conditions. This takes huge amounts of computer memory, and only in recent years with the advent of the supercomputer could reliable projections be made. The resulting projections do not bode well for us. We should be paying attention to the figures, which predict a harrowing future if we continue with business as usual. I was able to photograph a supercomputer at the University of Texas. It had a room with a set of large monitors where you could see the results in visual displays.

My main goal was to photograph scientists doing experiments in the field, but many of the scientists did most of their important work at computers inside offices. However, by reading articles in science and nature magazines, I discovered some scientists working in the new field of paleoclimatology. Paleoclimatologists piece together what the climate was like in years past to predict what might occur in today's conditions. They have discovered that ice cores, tree rings, and stalagmites all contain signatures within them that have recorded what the climate was like as they were formed.

The most powerful way to discover past climates and extreme weather patterns is to examine glacial ice cores. Each year snowfall is accumulated on the top of a glacier, and within the snow are atoms that contain the amount of carbon dioxide that was in the atmosphere at the time of deposition. Researcher Lonnie Thompson from Ohio State University has spent his career collecting ice cores from tropical ice caps. This requires hiking up some of the highest mountains in Africa, South America, and the Himalayas with a large drill capable of penetrating ice. Once the core samples are retrieved, he has to transport them down the mountain and back to a freezer in Ohio without allowing them to melt.

I went with Thompson on one of his expeditions to the Ouelccaya Ice Cap in Peru. We hiked to the summit at 18,600 feet, where I photographed his crew drilling the cores and preparing the ice to be transported down the mountain to a waiting ice cream truck. From there, the ice cores were driven to the airport in Lima and flown back to Ohio.

In the minus 20 C freezer in Ohio, I set up portable strobe lights to photograph Thompson holding a core sample from Peru. After a few minutes I spotted frost starting to form on Thompson's eyelashes. Thompson didn't seem to notice and just focused on the task at hand. It was a small element, but sometimes it is the little details that make a big difference.

I thought it was important to highlight the work of individual scientists who were documenting the effects of climate change. To me, these scientists, some of whom have faced political pressure in order to do their job, are heroes. In the future, I believe we will view them as prophets who few listened to during their time.

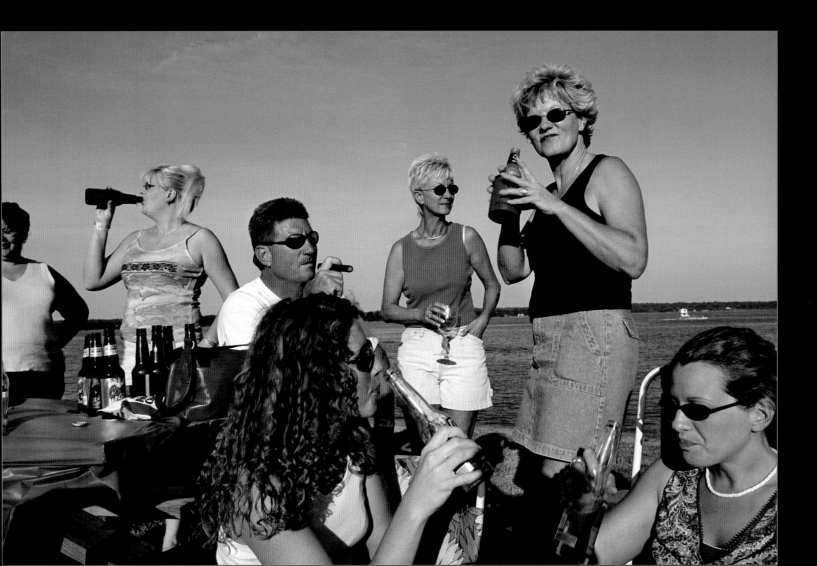

The Chesapeake: Why Can't We Save the Bay?

The *National Geographic* office in Washington DC is in the Chesapeake Bay watershed. There are advantages and disadvantages to doing a story about a place that the editors know so well. The editors may have a special passion for the story, but also a well-defined outlook that may be different than that of the photographer. In the end, it wasn't difficult to find compelling photographs for a story about the Chesapeake, because the issues were readily apparent.

The writer who proposed the story, Tom Horton, had covered the Chesapeake his whole career. He had seen that despite a lot of effort and money invested, the bay was still degraded with excessive nitrogen. The title of the story, *Why Can't We Save the Bay?,* summed up his frustration with decades of unfulfilled promises and half-hearted cleanup efforts.

Early on, I arranged a kayak trip down the Patuxent River in Maryland with Horton. The second night, we stopped at a campground along the shore for the evening. All at once, a large group of Harley motorcyclists pulled into the campground. A lot of drinking ensued, and the men held an impromptu contest for the biggest belly. It was all in good fun and made for some funny photos, but it wasn't what I was looking to photograph for an environmental story about the bay.

The next morning I got up early to see a beautiful sunrise with mist on the water. A waterman drove by in his boat, working his trotline for crabs. It was an example of the bay at its best. Over the course of the story, I ended up spending quite a bit of time with watermen. I went out one morning looking for crabs with James Eskridge, Jr., a young waterman on Tangier Island. I photographed a group of former watermen and women from Smith Island who now worked at a prison because it is no longer possible to make a living fishing the bay.

A few hours after photographing the waterman at sunrise, two recreational powerboats pulled up in front of me. Several people jumped out, sat down at a picnic table, and popped opened some beers. They called themselves the Battle Creek Gang; they were nice people, but they represented a type of lifestyle that was putting strains on the bay. The desire to live the good life has been the impetus for the suburban sprawl and intensive agriculture in the Chesapeake watershed. Recreation generates an estimated two billion dollars a year in Maryland, but it has come at the cost of a degraded ecosystem.

In the course of a few hours, I had illustrated both the beauty of a traditional waterman as he worked and the pressures the increase in population puts on the ecosystem. The main issue I had yet to illustrate was the pollution choking the bay. I found the most glaring example in a branch of the Patapsco River in Baltimore. It was described in the *Geographic* caption as "a good punt from the Baltimore Ravens' stadium." There was trash in the river alongside waterfowl, and freeways in the background. I also photographed a brown bullhead catfish in the Anacostia River in Washington DC that had cancer as a result of toxic runoff in the water. That was a sad sight to see in the waters of America's capital.

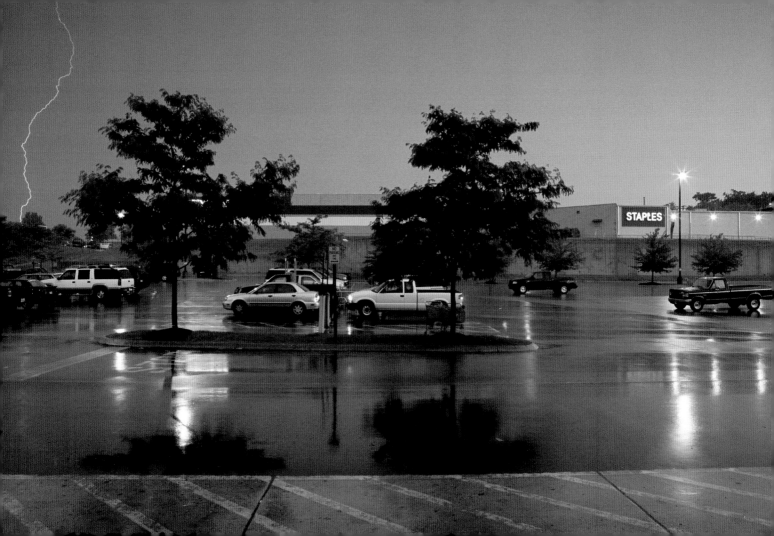

Afternoon Thunderstorm: Nonpoint Source Pollution

Nonpoint source nitrogen pollution comes from the runoff of rainwater across impervious surfaces. This is the major reason the Chesapeake Bay is polluted. I had done a whole story about nonpoint source pollution a decade earlier, so I knew about the issue and the difficulty of photographing it.

One afternoon, a thunderstorm developed while I was driving on the expressway in Baltimore. I pulled off the road and turned into a Home Depot parking lot. It was raining very hard, and I realized it was a great time to photograph nonpoint source pollution. In a parking lot, nitrogen, is deposited from the exhaust of vehicles as a by-product of the internal combustion engine. The deposits build up over time on asphalt or other hard surfaces, and then rain washes them into a sewer that eventually leads to a bay, river, lake, or ocean. In this case the pollution was headed toward Chesapeake Bay.

The only place I could set up my camera was under an awning in the entranceway to the store. There was a lot of lightning associated with the storm, and I did a series of eight-second exposures. One recorded a bolt of lightning in the distance. There were several other shoppers nearby waiting out the rain, and I think most of them wondered what I was photographing. I'm sure they would have been shocked if I told them I was from *National Geographic*. They would probably have been even more surprised that the photo of the parking lot was actually published in the magazine.

We tend to think of outdoor photography as something we do on vacation to record a person or place that is unusual. There are the many scenic overlooks that are photographed over and over, either alone or as a snapshot with a family member in the foreground. For most of us who live our daily lives in suburban America, a Home Depot parking lot is not worthy of a second glance, even in the middle of a rainstorm. However, I believe we should photograph not only exotic subjects, but everyday life as well. Many environmental issues revolve around the choices we regularly make: where we live, the vehicles we drive, the food we eat, and the products we buy. These are ordinary parts of daily life, but they can also be the subject matter for an artist with a keen vision. In fact, there is a long list of photographers who did their best work documenting their own backyards, two great examples being Ansel Adams in Yosemite and Edward Weston in Point Lobos, California. Robert Adams is the photographer I admire very much for photographing the real everyday world of Denver and the Colorado Front Range, where he lived. His unsentimental, yet powerful photographs capture the way we live our ordinary lives.

This parking lot photo is of a mundane subject, but it makes an important point about why it has been so difficult to save the bay.

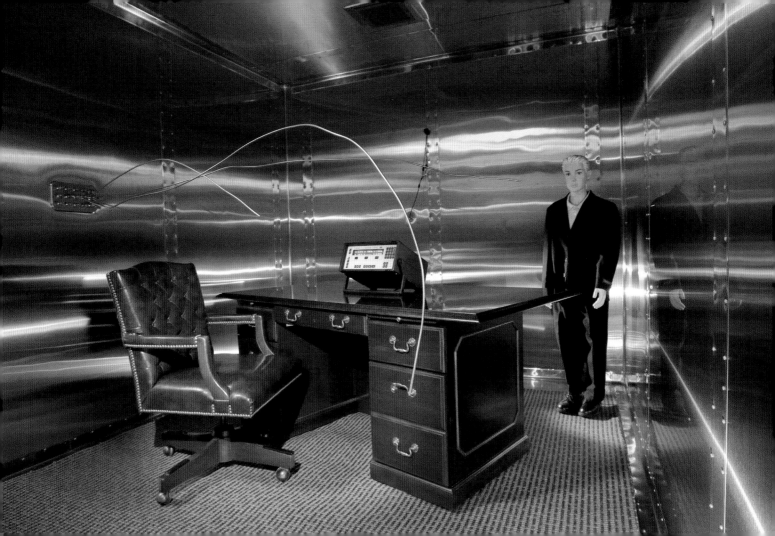

Modern Chemistry: Convenient with some Side Effects

In this room-sized, stainless steel environmental test chamber at the Georgia Tech Research Institute in Atlanta, researchers can monitor chemical emissions from an office desk, a chair, a rug, or even clothing. Chemicals are found in all these items, and many more of the products that we use every day. They are so prevalent that we don't notice most of them or realize that they are secretly entering our bodies and exposing us to danger. Chemicals help make our lives more convenient, so that eggs don't stick in pans, and they can make our lives safer, so that our mattresses don't burn in a fire. However, they can also disrupt our endocrine system and make us sick or give us cancer. Because there are so many chemicals in the environment, the real dangers are unknown and the long-term health effects are just beginning to come to light.

In 2006, I photographed a story for *National Geographic* called "The Pollution Within," about new science that can detect in our blood many of the chemicals we are exposed to on a daily basis. At last count, there were 82,000 chemicals in common use in the U.S., only a quarter of which had been tested for their toxicity. The writer of the story, David Ewing Duncan, had himself tested for 320 chemicals as part of his research for the story. He tested positive for 165. Most people don't have the time or money to get such an extensive test, but his results were considered average. Most of us have a similar cocktail of chemicals—sometimes called a body burden—swirling around inside of us.

Most people have traces of chemicals that were banned decades ago in their blood because these chemicals linger in the environment and break down slowly. These long-lasting chemicals include DDT and other similar pesticides, and PCBs that were used as electrical insulators. Chemicals often found more recently in blood are a family of phthalates used in shampoos and perfumes, and polybrominated diphenyl ethers (PBDEs) used as flame-retardants in a whole series of products.

A small percentage of people suffer from a condition called multiple chemical sensitivity. Near San Francisco, California, I photographed Betty Kreeger, who had worked as a policewoman but was unemployed because she found it so difficult to function in a world full of chemicals. When I called her to ask about photographing her, she instructed me to not wash my clothes in any detergent before coming to see her. When we went into a grocery store, she had to don a charcoal mask to get through the aisles. On the same trip, I also arranged to photograph three women with breast cancer who all had lived near an oil refinery in Richmond, California. I found a hill overlooking the plant and arranged to photograph the women at sunset. One of the women, without me asking, brought an enlargement of a photograph she had taken after having had a mastectomy. It was quite graphic, but exemplified the issue of breast cancer and chemical exposures.

The article about the chemicals in all of us was challenging to do at the time. However, I believe it is one of the most important articles I have done during my career because I felt I was presenting important information to people who may not have been informed about the potential gravity of our toxic environment.

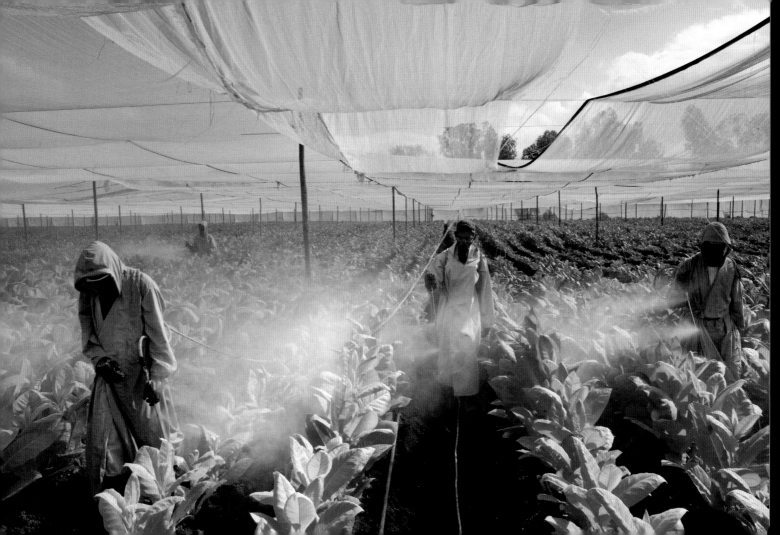

Nicaraguan Grown: Cigars with a Touch of Fungicide

It is a well-known fact that many dangerous pesticides that are banned in the developed, industrialized world are still used in other, less-developed countries. As a photographer, I also discovered that it was easier to photograph the spraying of pesticides in Central America than it was in the United States.

I took this photo of sprayers applying a fungicide called dithiocarbamate to a tobacco crop in Jalapa, Nicaragua. The workers have to apply this chemical about every four days to keep the tobacco salable for export cigars. One of the workers there told me that he had been ill a few days before from the fumes, but he was back on the job because he needed the work.

After I returned home, I did a little research about the fungicide dithiocarbamate. First of all, the fungicide is legal in the U.S. and it is widely used in agriculture. According to a fact sheet put out by the state of New Jersey, dithiocarbamate poisoning may occur if excessive amounts of spray or dust are inhaled. Symptoms include cough, inflammation of the throat, skin rashes, and redness of the eyes. The good news is that dithiocarbamates do not accumulate and persist in the body. The bad news is that once in the body, dithiocarbamates can turn into ethylenethiourea, which is considered by the U.S. Environmental Protection Agency (EPA) to be a probable human carcinogen. Also, long-term exposure to high levels of dithiocarbamate fungicides can result in abnormal thyroid function. Furthermore, dithiocarbamates have been shown to cause reproductive and birth defects in laboratory animals.

There are many other pesticides in wide use that are probably more toxic than dithiocarbamate. The pesticide dibromochloropropane (DBCP) was banned in the USA in 1977, but in one lawsuit, banana workers claimed that growers continued to use it in Central America for many years afterwards. There are 7,000 cases of acute pesticide poisoning reported each year in Central American countries, and the World Health Organization estimates the number of cases worldwide to be three million.

There is a significant social justice component to environmental issues: workers in the developing world are exposed to levels of toxic chemicals that would not be acceptable in the industrialized world. Eating organic foods is most likely good for your health and good for the soil, and it is beneficial to agricultural workers. With all those benefits, it seems like more of us should embrace organic foods.

The website organic.org lists ten reasons to support organic agriculture in the 21st century. I like reason number 10 the best:

"Celebrate the Culture of Agriculture: Food is a language spoken in every culture. Making this language organic allows for an important cultural revolution whereby diversity and biodiversity are embraced and chemical toxins and environmental harm are radically reduced, if not eliminated. Organic is not necessarily the most efficient farming system in the short run. It is slower, harder, more complex and more labor-intensive. But for the sake of culture everywhere, from permaculture to human culture, organic should be celebrated at every table."

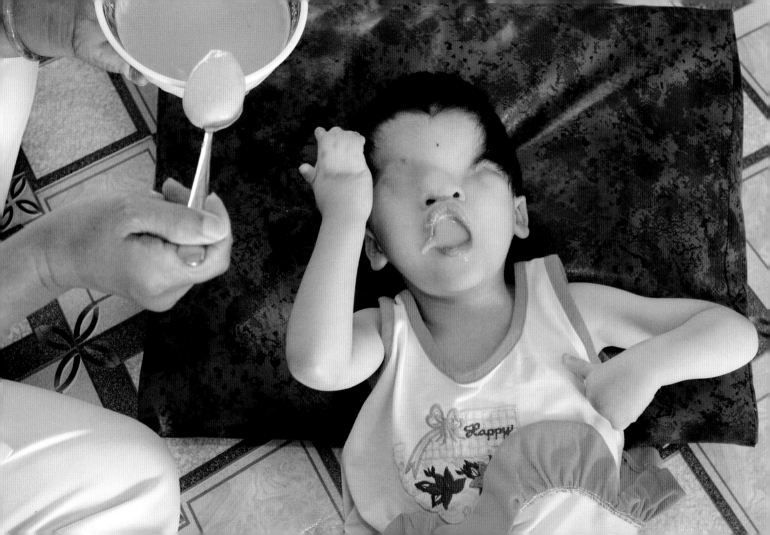

The Eyeless Child: Looking for Justice in a Dark World

In recent years, journalists have become known more for their coverage of celebrities and sensational stories than as crusaders for justice and the unprivileged. To be sure, sensational journalism has been around since the beginning of newspapers; however, around the turn of the last century, photographers like Jacob Riis and Lewis Hine pioneered a form of documentary journalism aimed at exposing social ills. Many journalists who followed were inspired to continue the good fight and saw journalism as a calling just as much as a profession. The legendary newspaper editor Joseph Pulitzer once summed it up by saying the role of the journalist was to "comfort the afflicted and to afflict the comfortable."

This notion came under attack, primarily in the post-Watergate years. Some have said that journalists themselves are a group of elites, hypocrites for espousing anti-American ideals. Certainly many journalists come from privileged backgrounds, but I don't see that as a reason to abandon the crusading role. It is my belief that now, more than ever, journalists should try to shed a little light in the dark corners, however difficult that task can be.

When I was working on a *National Geographic* story on the hazards of toxic chemicals in our society, most of the coverage was centered on everyday chemicals found in paints, detergents, and cleaners. These chemicals can enter our bodies in low doses and do harm over time. However, one aspect of the story was those situations where an individual or group had been exposed to high doses of chemicals, such as in an accident, or because of a war. The effects of this type of exposure can be disastrous and can affect not only the person exposed, but also their offspring.

The Agent Orange victims in Vietnam are a particularly horrific example of the ill effects of high dose exposure to dioxins. I was able to photograph at the Peace Village in Ho Chi Minh City (formerly Saigon), where about 60 children with severe handicaps live. The children, from villages around Vietnam, were brought to the Peace Village by their parents who were unable to care for them. During the Vietnam War, people were exposed to Agent Orange in such powerful doses that it altered their DNA. As a result, their children and grandchildren are being born with severe deformities. The young girl without eyes or fingers in the photo has Fraser Syndrome, a malformation likely caused by the previous generations' exposure to Agent Orange.

When I approached the girl, an attendant was feeding her breakfast. I took just a few photos and moved away. These situations have always been uncomfortable for me as a photographer. It is easy to feel like a sleazy opportunist for just taking pictures and leaving. I remind myself that I am trying to tell a story, and that I would only photograph what I'd feel comfortable photographing of my own family.

I thought I might get a bad reception in Vietnam because I'm an American, but that was not the case. I was treated warmly everywhere I went. Perhaps the people I met understood my mission, or perhaps the Vietnamese are just very forgiving.

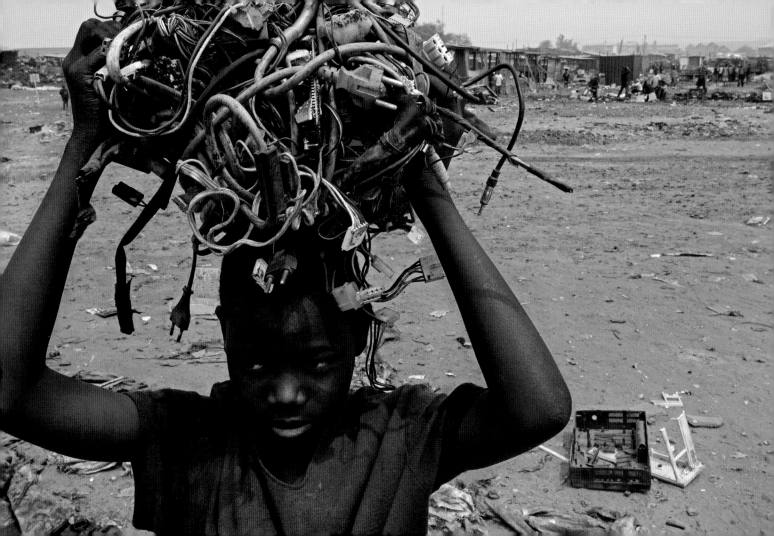

Chance Encounter: A Symbol of Technology Gone Wrong

In the realm of environmental issues such as climate change and the lack of clean freshwater, high-tech trash—or e-waste—might seem to be a minor problem. After all, aren't technology and computers, which make information readily available and connect people around the world, a good thing? And doesn't e-waste give recycling a bad name? Perhaps the answer is yes to both questions, but e-waste is still a compelling and important issue.

We generate a lot of high-tech trash these days. Every computer, cell phone, VCR, or other electronic gadget that was once a marvel but is now a clunker must end up somewhere. A lot of us simply put them away in the attic, either because we don't know what to do with them or because they contain important personal information on a hard drive. It turns out that this isn't the most efficient way to discard old electronic devices, because they contain valuable metals and plastics that should be recycled rather than be mined anew. Some e-waste does make it to e-waste recyclers, but some of these businesses have been irresponsible, and send the less valuable items to poor countries rather than recycling on site. In countries such as Ghana, China, and Pakistan, workers pick apart e-waste in conditions that are often unsafe and environmentally unfriendly.

When *National Geographic* accepted my story proposal on high tech trash, I set out to find the most interesting locations to photograph improperly recycled e-waste. This turned out to be a difficult job since most of the work is done illegally and countries that participate in such practices usually tend to deny that they are accepting trash from the U.S. or other developed nations. One organization, The Basel Action Network

was most helpful and told me about a location in Accra, Ghana where e-waste from the U.S and Europe was being illegally recycled.

When I went to Accra, I discovered that there was a drop-off spot on the edge of a shantytown. Middlemen bought large lots of e-waste that had been trucked in from the port a few hours away. Workers then bought individual pieces of waste and stripped the copper wires out of them. The wires were then carried to an empty lot where the plastic was burned off and the copper was sold to another middleman.

It was between the shantytown and the burn lot that I saw a young boy carrying a load of wires on his head. I took just a couple of frames as he noticed me. I asked the man who was working with me to talk to the boy. The boy wouldn't give his name, but he told us he was 10 years old and had come to Accra from the north of Ghana because his family could no longer farm the land on account of a drought.

During the course of this assignment, I took pictures of all sorts of e-waste and many people doing the recycling work. However, this is the picture that people—usually stock photo buyers, environmental organizations, and college students doing term papers on e-waste—request the most often. I believe this is because it puts a human face on an issue that can seem quite distant. For me, these photo opportunities are like gifts that often come for only a split second. It is up to my reflexes and training as a photojournalist to see them, photograph them, and then pass on the picture so others can share in the experience.

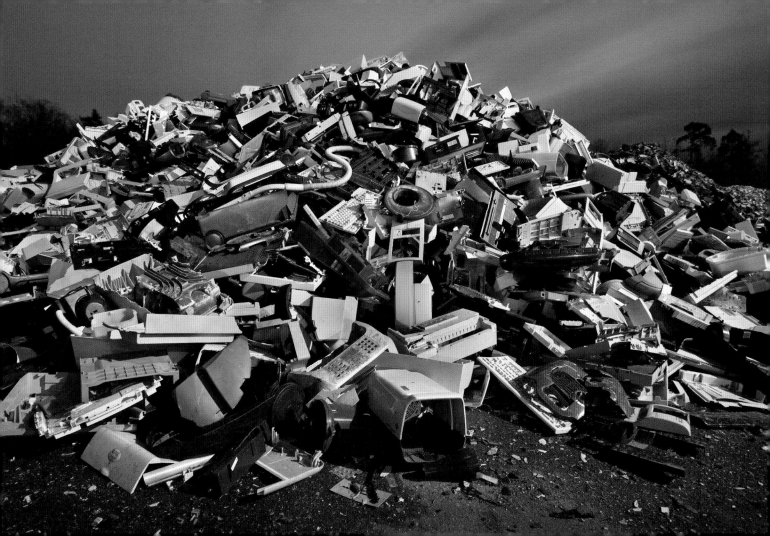

Plastics: Cheap, Durable, and Hard to Recycle

At MBA Polymers in Kematen, Austria, plastics from electronics are recycled in a sophisticated manner for reuse in injection and intrusion molding. In the laboratory, each load is sampled and the amount of plastic, wood, metal, etc. is determined. In the European Union, plastics must be recycled, if possible, and incinerated if it is not possible to recycle them.

During the course of doing the story about electronics waste, I discovered that plastics are the least desirable part of any product in terms of their economic value for recycling. In many backyard-recycling operations in Ghana, India, and China, I saw workers strip out the circuit boards and copper wires, and then throw the plastic carcass of a computer or similar gadget into a dump or even into a riverbed.

Plastics are organic, synthetic polymers that are usually derived from petrochemicals. Most often, they are based on a chain of carbon atoms, but they can also include oxygen, sulfur, or nitrogen. It takes two to three times more energy to make plastics from crude oil than it does to make paper from timber. Keep that in mind the next time a clerk at the supermarket asks whether you want plastic or paper.

Plastics contain additives that include flame-retardants, plasticizers, and colorants. Some of the additives, such as bisphenol A, or BPA, have caused more controversy than the plastic base material. BPA used to be in all water bottles, but has been shown to be an estrogen-like endocrine disruptor that can leach into water and food. Phthalates, which are often added to brittle plastics for use in food packaging, toys, and many other products, are suspected human carcinogens and may interfere with hormonal systems.

Despite these concerns, plastics are popular because of their durability, cheap price, and light weight. However, the durability of plastics is also the reason they last so long in a landfill or out in the ocean. It is estimated that the one billion tons of plastic that have been thrown away since the 1950s will persist in the environment for hundreds or even thousands of years. The Great Pacific Garbage Patch, an area of the Pacific Ocean that may be as large as the continental United States, has exceptionally high concentrations of discarded plastics mixed in with chemical sludge.

I am not sure what to make of all the plastic in our modern lives, but as long as we have it, we should learn how to recycle it for the good of the environment. Most plastics can be remelted and reused, although the purity tends to degrade each time. The greatest difficulty in recycling plastics is the labor-intensive sorting process. They have to be sorted out from other materials, and then sorted again by plastic type. The numbers on the bottom of plastic bottles surrounded by the chasing arrows are resin identification codes, which categorize bottles into seven common types. However, a single cell phone can consist of over a dozen types of plastics. One new recycling process called Vinyloop can separate PVC from other materials through a process of dissolution and filtration. Plastic parts of temporary buildings used in the 2012 London Olympics were recycled using this elegant approach.

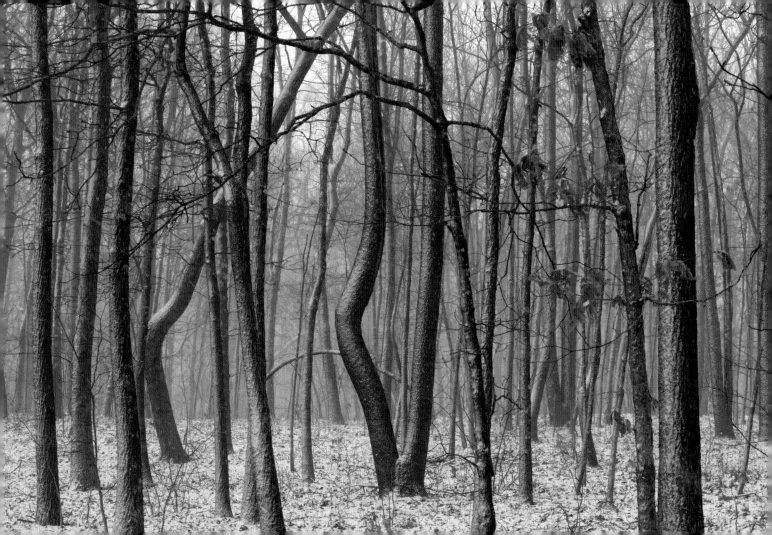

An Ozark Snowstorm: Worth the Drive

In 2008, I was working on a story about the Ozark Highlands Trail in Arkansas. The trail is 165 miles long and was constructed completely by volunteers. It passes through many remote and beautiful hardwood forests. I wanted to photograph the trail in all the seasons. The winter was the most difficult; in recent years there had been little or no snow. When it did snow, it was just a dusting that usually didn't last for long.

One evening in my home city of Atlanta, I heard about a storm heading for Arkansas. Ironically, that night I was giving a lecture about climate change. I decided I had to leave for Arkansas immediately after the talk, since it might be my only chance to photograph snow in the Ozarks. White Rock Mountain, about a 14-hour drive from Atlanta, is the highest elevation on the trail. At 2,320 feet, it had the best possibility of getting snow.

I drove all night and arrived at White Rock Mountain the following day at about one in the afternoon. The top of the mountain was in a cloud, and was getting a small, but significant dusting of snow. The light snow, dark bare trees, and misty light created an unusual effect. The whole forest looked like a charcoal etching. I spotted a section of the forest where two trees were bent in a similar fashion. I'm not sure why those two trees grew that way, but it made for a curious graphic element. The small birch tree on the right still had its leaves, and completed the composition by adding some color to the scene. I used a slight telephoto lens to accentuate the atmospheric effect.

Nature photography, and perhaps every form of photography, is all about timing. With news photography there is a saying that sums it all up, "f/11 and be there," which means that being on the scene is more important than worrying about technical details.

For snow scenes, a photographer has to go out in the storm, even though this can be hazardous. Photographs of falling snow often make for great atmospheric effects. Usually after a snowstorm, there is a short period of clearing clouds and sunlight when you can photograph the scene before the snow starts to drop from the trees.

For this picture of the Ozark snowstorm, the opposite effect happened. The more it snowed, the more the charcoal effect disappeared. The following morning the sky was clear, and there was about two inches of snow on the ground. The scene didn't look special at all. The snow started to melt by the afternoon, and by the following day it was all gone. As it turned out, I'd hit a window of about two hours when all the elements were in place. If I had waited until the morning to leave from Atlanta, I would have missed it.

This photograph of the snowstorm on White Rock Mountain has been one of my most popular prints. I don't recommend driving all night with little sleep, but in this case the result made the long, somewhat risky drive worthwhile.

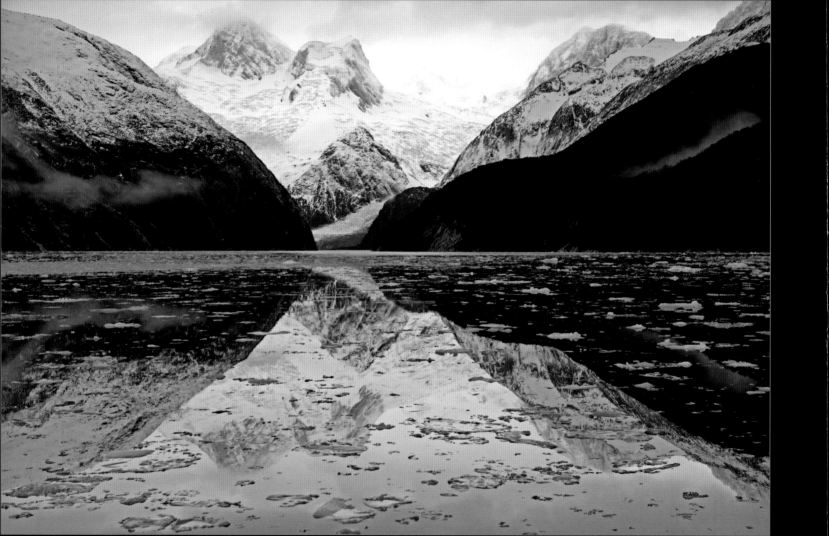

Darwin at 200: An Extraordinary Voyage and Place

In 1831, a young, recent graduate of Cambridge University named Charles Darwin boarded His Majesty's Ship (HMS) Beagle for what would be a five-year expedition devoted mostly to surveying the South American coastline. Darwin was invited on the voyage as a companion of the ship's captain, Robert Fitzroy, but assumed the role of the naturalist during the journey. His diary of the expedition was turned into a travel book that became known as *The Voyage of the Beagle.*

In 2009, *National Geographic* planned an article to commemorate the bicentennial of Darwin's birth and the 150th anniversary of the publication of *The Origin of Species.* The photographer working on the story had a family emergency, and I got a call to fill in on the planned trip through the Beagle Channel. The boat had already been booked for a winter trip from Ushuaia, Argentina, to the Darwin Cordillera in Chile. My task was to get a single photograph to represent the beautiful landscape the Beagle passed during the second year of the voyage. This is a very remote part of the world near the tip of South America, and the winter weather can be notoriously stormy and unpredictable.

I accepted the assignment, and flew down to Ushuaia to board the yacht for the 10-day private trip. There was a captain, an assistant, and a cook waiting for me. We set out by motoring west through the waterway that separates the mainland of South America from the large island of Tierra del Fuego. We had to take extra safety precautions because we would be alone in the wilderness for the entire 10 days. I soon realized some of the creative difficulties I would face: almost all of my photography had to be done from the boat. In order for anyone to get on land, we would have to find a sheltered lagoon. For the boat to be secure in deeper water, we would need to anchor it twice: one anchor going to the ocean floor and another being tied to a rock or tree on shore. We'd need to take the second anchor to shore in a small zodiac boat. The whole process would take over an hour, and I soon learned that we would only do this in places where we intended to spend the night.

My main destination was Pia Bay, where it looked like I could get a picture of the tidewater glaciers and the rugged Darwin Cordillera in the background. On January 29, 1833 Darwin wrote of this spot, "It is scarcely possible to imagine any thing more beautiful than the beryl-like blue of these glaciers, and especially as contrasted with the dead white of the upper expanse of snow." However, thanks to the short days and the delays in getting our passports stamped to pass from Argentina to Chile, our 10-day trip became rushed. It was apparent that I might not get to spend even one whole day in Pia Bay.

When we arrived in one section of the bay in the late afternoon, it was overcast and grey. Despite the fact that most of the trip had been choppy and windy, there was a strange stillness in the air. I asked the captain to slow the boat down as much as he could while still moving, and I went to the front of the boat to take photos. I barely had enough light to get a sharp photo, but the scene was extraordinary to witness. I was able to get some other photos on land the next day, but the scene that I photographed on arrival turned out to be the best.

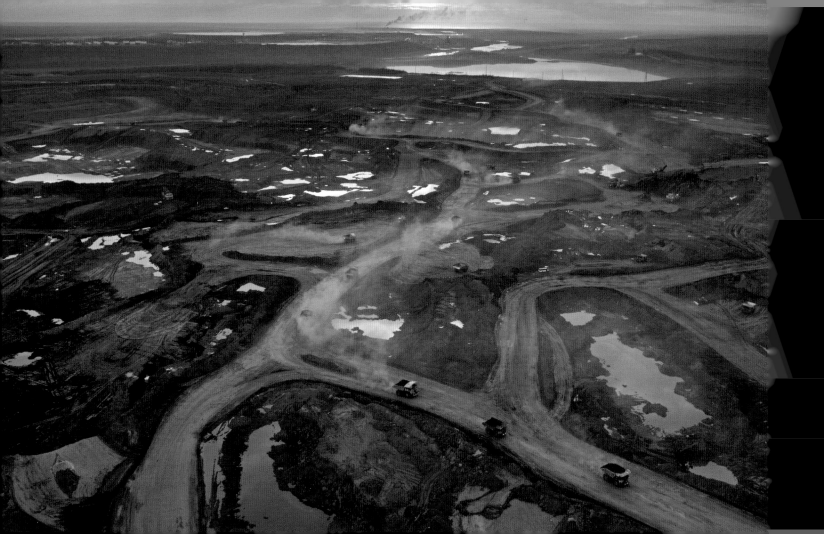

Canadian Oil Sands: Money Can Justify Anything

Everything about the Canadian Oil Sands is large, difficult, and controversial. Even the name is a source of disagreement, with critics preferring the somewhat pejorative *tar sands*.

Nowhere on Earth is more soil being moved than in the Athabasca Valley near Fort McMurray, Alberta. Here, about a hundred feet below the boreal forest, there are large deposits of bitumen mixed in with sand, clay, and water. In order to extract the oil, the industry must first cut down the forest. Then for every barrel of oil recovered, industry must remove two tons of topsoil and dirt that lies above the oil sands layer, then another two tons of the sand itself. The sand must be heated—usually with natural gas—to extract the bitumen. The excess suspended sand, clay, and unrecovered oil is released back into tailings ponds.

The process is straightforward, but difficult, costly, and hard on the environment. Most of the oil is exported to the U.S., a customer that is happy to get a guaranteed supply from a friendly neighbor. The proven reserves make Canada second only to Saudi Arabia as a supplier of oil on the world market. The bottom line is that the oil sands generate a lot of jobs and tax revenue for Alberta.

In doing the photography for this story, I learned a lot about human nature. I came to the conclusion that if you pay someone a high enough salary, they will do almost anything. While having a steady job is good, living in a boomtown and sharing the boomtown mentality is usually not good for the human psyche. People tend to waste money on frivolous things just because they have money to spend. Housing prices become inflated beyond belief, and public services, such as roads and water treatment facilities, can't keep up with the large influx of outsiders streaming in to try to make a quick buck. Often, this abundance of disposable income breeds a culture that is quick to perpetuate certain societal ills, like drug use and prostitution.

Beyond the lessons about human nature, the Canadian Oil Sands is an important story. Before I did this story, I thought that if the price of oil went up high enough, alternative energy sources, such as solar and wind power, would become more competitive and become more widely used. This is true to a point, but what also happens is that higher oil prices make unconventional oil or difficult-to-recover oil more economically viable. Simon Dyer of the Pembina Institute is quoted in the *National Geographic* story as saying, "The oil sands represents a decision point for North America and the world. Are we going to get serious about alternative energy, or are we going to go down the unconventional oil track? The fact that we're willing to move four tons of earth for a single barrel really shows that the world is running out of easy oil."

There is a lot of difficult-to-recover oil out there, but according to the climate change models, we must make a decision to leave it in the ground and switch to non-carbon fuel sources now. However, as the booming oil sands industry reveals, this switch isn't happening, and we all should be concerned.

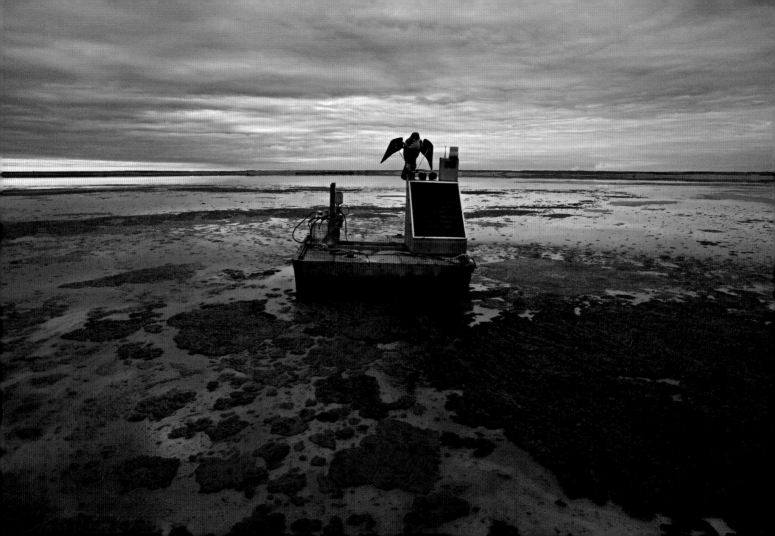

A Tragic Beauty: Two Wings to Fly

The early September dawn was cool, which was normal for this time of year in northern Alberta. Across an artificial lake, the horizon disappeared into a dense, hazy fog. There was mist coming off the water, breaking through a rainbow-colored sheen of oil on the surface. At a small dock, the new all-steel workboat was splattered with pitch-black bitumen, but idling and ready to go. It had taken several weeks and many phone calls to arrange, but finally I was about to take a boat ride on the Shell Albian Sands tailings pond.

Shell was one of three major players in the oil sands development in northern Alberta, Canada. They had given me permission to photograph their tailings pond even though the tailings ponds were the most contentious part of the highly controversial oil sands operations. A year before, migrating ducks had landed on a nearby tailings pond and drowned, causing a public relations nightmare.

Shell developed a high-tech solution in an effort to keep birds from landing on their tailings pond. When lasers detect a flock of ducks, it sends a signal to several solar-powered effigies of peregrine falcons that are situated around the lake. The falcons are natural predators of ducks, so when the effigies start to flap their wings and a recording of their call is played, the ducks will hopefully fly away. For Shell and perhaps some other supporters of the oil sands, this was an elegant solution to the problem. For others, it seemed rather strange and tragic to use technology to try to fix what technology was damaging in the first place.

Environmental pictures that are too direct seem to have almost lost their meaning. We see them all the time as a B roll on CNN. Surveys say that many people are tuning these images out, whether out of fatigue, denial, or a combination of both. Visual artists who want their work to address these issues need to use a different approach.

I believe this picture is successful because of the competing elements, which open up the photograph for deeper interpretation. The dark sky and the oil sludge on the lake certainly are threatening elements. However, the solar panel on the red platform, the falcon photographed from below and placed in the center of the frame, and the sliver of the sunrise add a counterpoint of beauty and hope.

Perhaps a good environmental photograph, like our life on this planet, is a complicated duality. On one wing, we need things like development to form civilizations. The stark reality is that we have to tolerate politics, and we need industry to provide energy to drive our cars and light our homes. But on the other wing is the realm of the artist, the visionary, the preacher, and the free thinker. Their message is a desire for justice, freedom, a New Jerusalem, or a Love Supreme. We believe and have faith that reason will prevail and harmony with nature is possible.

We live in these two worlds and sometimes one photograph can speak to both. Perhaps it can even make us realize that, just like a real peregrine falcon, it takes two wings to fly.

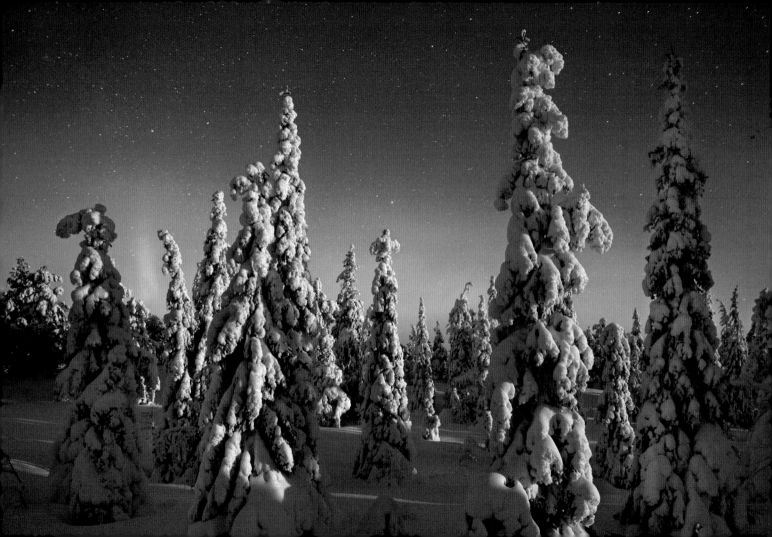

Finnish Moonlight: Sometimes it All Works Out

For a story on the Oulanka National Park in Finland, I arranged three two-week trips. The first was in early summer, timed for the best hiking season, the midnight sun on June 21, and the wildflowers. The second trip was in fall for the autumn colors. The last trip was timed for two weeks in February, when there is usually still snow on the ground, but there are more daylight hours than in December or January. That two-week period also was chosen to include the full moon.

Located in the Boreal forest, Oulanka features pine, spruce, and birch trees. The spruce trees are at a low elevation and get lots of water, so they grow very tall. The local people call them candle spruce. I was told that if the temperature reached minus 20 degrees C that the falling snow would cling to the trees. In my head I dreamed up a picture of a forest of candle spruce trees lit by moonlight with the northern lights glowing in the background.

When I arrived, the temperatures had been warmer than normal (climate change?) and there was no snow clinging to any of the trees. I found a forest of spruce with a clear northern sky in the background, but I still needed more snow and the temperature to drop. Also, the Aurora reports from the Geophysical Institute in Alaska were showing that this was a period of very low activity of the northern lights.

Finally the temperature dropped, and I determined I would have three nights of moonlight to get the shot. My guide, Olli, and I hiked half an hour to get to the top of the fell where I planned to shoot. The first night, we discovered that the light from a nearby ski resort that offered night skiing was casting a ghoulish orange glow on the scene. We were freezing, so when it got cloudy, we walked back.

The next night, we changed our plan slightly. We went to the ski area and waited for the resort to turn off the lights. I had read that carbs and nuts help keep you warm at night because they take up to eight hours to digest. For dinner we each ate a large pizza and took along some cashews. The second night was clear, and we were warmer, but there were no northern lights.

The third night, we were back with more pizza and cashews for my last chance at getting the shot. It was clear, and because the moonlight came up an hour later, the low light caused a 3D effect on the trees. Olli came snowshoeing over and said that he had seen some aurora activity. The activity was only a 1 out of 9 on the scale, but it was just enough.

Many of my successful photographs are the result of discovering a scene and then going back several times to get the best picture possible. This photograph is the result of having an idea and then executing it despite the obstacles. Life can be hectic and problematic, and we can become disappointed when things go wrong. But when it all works out, why not take some time to celebrate? In Finland, that included a meal of chanterelle mushrooms with lingonberries and sweet pulla bread, followed by a nice sauna.

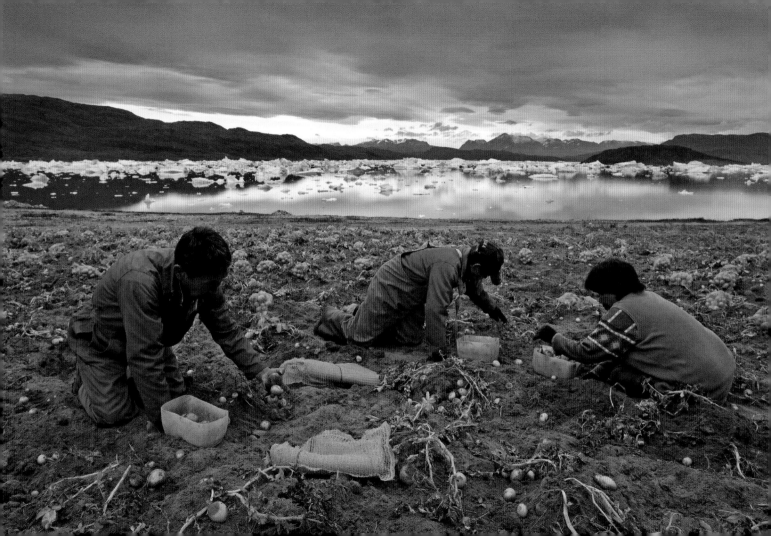

Adapting to Change: An Example from Greenland

The process leading up to the capture of this photo of Inuit workers harvesting potatoes in late August in Greenland began on a hot June afternoon in Atlanta. I was beginning my fieldwork for a *National Geographic* story called "The Greening of Greenland." The central theme of the story was that temperatures in southern Greenland had warmed at twice the global average over the last 30 years. The warmer climate was melting the icecap with dire consequences for global sea levels. However, it was making it possible for the Inuit to become farmers, because the summers were now long enough to support agriculture.

My plan was to fly from my home in Atlanta to Boston, catch an overnight flight to Reykjavik, then transfer to an Iceland Air flight to Nuuk, the capitol of Greenland. I would stay overnight in Nuuk, and then fly Air Greenland on a twin prop to Narsarsuaq. Finally, I'd transfer to an Air Greenland helicopter and fly south to Qaqortoq, the main village in the south of Greenland. From there I could begin my work.

As my plane taxied for takeoff at Atlanta's Hartsfield-Jackson Airport, the pilot announced a delay in our departure because of traffic in Boston. After two hours of idling on the tarmac, I realized I would miss my flight to Iceland, and in turn miss my flights to Nuuk and Qaqortoq. In the end, I arrived in south Greenland a week later than I had planned as a result of that two-hour delay in Atlanta.

Upon arrival, I learned that not only had I lost precious time, but also that South Greenland had been unseasonably dry that June. None of the fields had yet sprouted and turned green. Also, none of the farms I saw were near ice fields, so they didn't look much different from farms in other parts of the world. One positive aspect of that trip was that I met a surveyor named Poul Erik who had visited just about every farm in southern Greenland. He told me about two brothers who had a potato farm near an ice field, and offered to be my guide and translator if I came back in August.

Fortunately, I was able to return, this time without any missed flights or delays. Poul Erik had found out that the potato harvest at the brothers' farm was planned for August 26 and 27. We arrived by boat on the afternoon of the 25th, and my heart dropped when I saw that the harvesting of the field nearest to the water had already begun. When you meet a farmer, the custom in Greenland is to go to his farmhouse, have some tea and biscuits, and get acquainted. I knew I had no time to spare, so I broke custom, jumped out of the boat, and started shooting.

This picture tells an important story of cultural change brought on by climate change. The elements are all there: the melting icecap, the land, the potatoes, and the Inuit, former hunters who are now becoming farmers. The scene looks organic, as though I just happened upon it, but nothing could be further from the truth. It took a lot of hard work and some heartache to achieve, but when I look at the image I feel quite satisfied. Of the thousands of pictures I took in Greenland, this serene scene of the Inuit farmers adapting to their new world in the soft, northern light is my favorite.

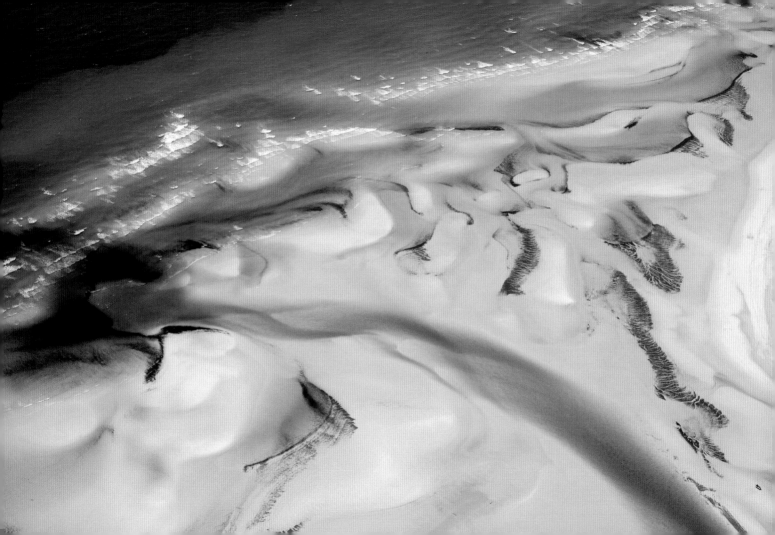

Midday Light, Low Tide: The Best Time to Photograph

For most nature photographers, sunrise and sunset are the prime working hours. This is the time when the low angle of the sun creates the best lighting for landscape photography. It's when the color of the light is warm because the bluish light reflecting off the atmosphere is less visible. The golden hour is sometimes known as the sweet light. For most nature photographers, "chasing the light," as Jim Brandenburg once described his working style, is a way of life.

At sunrise, the air is often clear and crisp. In the early spring or late autumn, mist rises from lakes and rivers in the early morning. It is hard to get up at 4 a.m., hurriedly get dressed, grab your equipment, and drive to a location to catch the sunrise, but the results are worth it. I love the feeling of having taken a nice photograph at sunrise and then going out for breakfast. It seems like all is right in the world when you sip hot coffee and enjoy a sense of accomplishment so early in the day.

Sunset is also a wonderful time to photograph. In the summer, people and wildlife often come out around this time as the air begins to cool down. The mood relaxes as the workday ends and nighttime approaches. Sunset is easier for photographers than sunrise. It can be difficult to photograph at sunrise if you haven't previously scouted the subject and location because you have to find a composition in near darkness. At sunset, the photographer has had time to find the subject in daylight. As the sun sets, the light just keeps getting better and better.

There are problems with photographing at sunrise and sunset, for sure. Many subjects have been seen this way so many times they have become a cliché. Does anybody need to see another sunset on the beach? Some contemporary photographers have reacted to this by trying to photograph more in the middle of the day. Kathryn Kolb is one of the few nature photographers I know who says that she prefers the midday light. She has produced many beautiful images, often working at close range, with backlight from angling the camera upward toward the sun. For myself, the dynamic light of sunrise and sunset is still more appealing. I am amazed at some of the unusual effects that can happen for a few moments just after the sun rises or before it sets.

One exception was when I set out to photograph the Wathumba Creek Estuary on Fraser Island, Australia. The creek is coffee-colored from all the carbon nutrients in the water. It flows into the ocean on the western coast where the water is a clear blue-green. At low tide, the sandy beach is visible along with the carbon-colored residue left as the tide goes out. In the middle of the day, the sun penetrates farther down into the water to bring out the intense colors. This photograph, taken at midday, is an exception to conventional wisdom, but perhaps the best rule is to not always follow the rules.

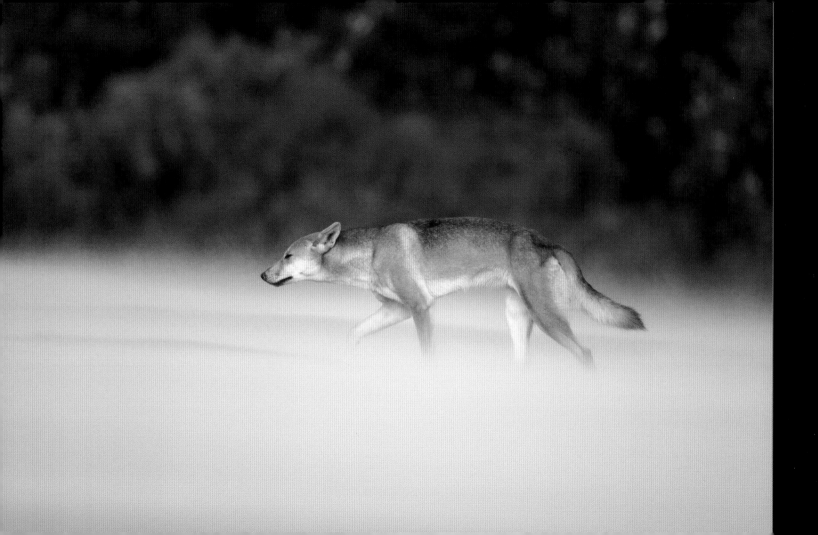

Fraser Island: Pure Dingoes and Dunes

At 72 miles long, Fraser Island, off the coast of Queensland, Australia, has the distinction of being the largest sand island in the world. For the last 750,000 years, ocean currents from the southeast have been washing sand ashore, where it collects on volcanic bedrock.

The island is a phenomenal place for a landscape photographer. There are sand dunes, of course, but there are also rainforests, eucalyptus woodlands, mangrove forests, wallum, peat swamps, and coastal heaths. If you have a special four-wheel drive vehicle with sand tires, everything is pretty accessible as long as you learn how to drive on the beach at low tide and avoid getting your vehicle stuck in deep sand.

Sand dunes are always a good photographic subject, and Fraser Island has many varieties. Along the eastern coastline are foredunes that are 100 to 200 feet high. They are vegetated with beach spinifex and pandanus trees. On the island's interior, the high dune ridges are between 300 to 700 feet high, and white sand mixes with darker, coffee-colored sand. There are 50 strikingly beautiful freshwater lakes in this part of the island. The oldest deposits of sand, which have a brighter orange color, are along the western coast.

I worked with photographer Peter Meyer on the assignment. Peter works as a guide for the Kingfisher Resort, but has also spent many years photographing on the island. He showed me all his favorite spots. One morning, we were out photographing on the Tukkee Sand Blow. A sand blow is formed when heavy winds blow sand not stabilized by vegetation across the island. These mobile sand dunes often overtake and bury large trees and other plants. Then, pioneer plants move in and colonize the dunes, and the sand becomes vegetated again. The whole cycle can take one thousand years or more.

The sunrise lighting on the sand blow wasn't too good, but we happened to spot a dingo out on the dunes, which Peter said was a rare sight. The dingo was walking into a strong headwind, looking and smelling for bits of vegetation that might blow his way, and it didn't pay much attention to me.

No one knows for sure, but it is hypothesized that dingoes came to Australia about 4,000 years ago with seafarers from Southeast Asia. Recent DNA evidence supports this theory. A dingo is not classified as wolf or a dog—it is somewhere in between the two—but there has been a lot of recent cross breeding with Australian dogs. The dingoes on Fraser Island are said to be the most pure in Australia, and in an effort to preserve their purity, no dogs are allowed on the island. In 2001, a young boy wandered away from his family's campsite on the island and sadly, was found dead, presumably mauled by a dingo. This led park rangers to kill over 120 dingoes as a reaction to the incident. By 2009, it was estimated there were only 100 to 120 dingoes on left on Fraser Island, and their numbers are still decreasing.

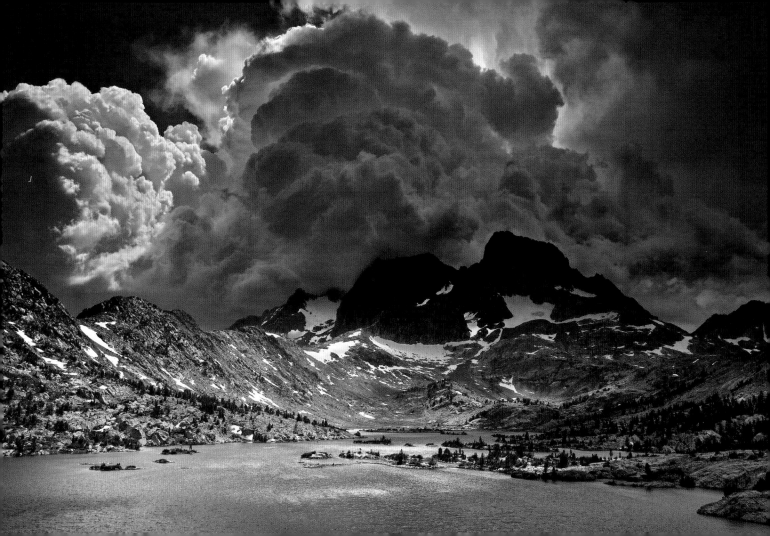

Ansel Adams Wilderness: Let the Mountains Talk

On a summer afternoon in 1923, a young, unknown photographer named Ansel Adams stood on the bank of Thousand Island Lake in the High Sierra and took a picture with a glass plate camera. He used a new panchromatic emulsion that allowed him to better render the thunderclouds building behind Banner Peak. This was the first of many masterful pictures to come for the photographer, who went on to become one of the most famous in the history of the medium.

Fast-forward 87 years to August 8, 2010 at 3:18 p.m. Another photographer, this one not so young, is standing on a granite ledge beside Garnet Lake in the same High Sierra wilderness that is now named for Ansel Adams. Peter Essick takes a photograph of the lake and the thunderclouds beyond it with a digital camera. The light passes through a wide-angle zoom lens for 1/125 of a second and electronically charges 21,026,304 pixels on a sensor. The data is then processed on a computer chip and transferred to a memory card.

Of the many photographs I've taken in my life, this one stands out. Many viewers have told me they can see the awesome forces of nature or the handiwork of God in the image, and they are uplifted by it. However, when I took the photograph, my focus was on more mundane things, like finding the right angle, anticipating the changing lighting conditions, getting ready for the coming rain, and wondering where to sleep that night.

The elements of the photograph can be described in scientific terms. The prevailing winds from the west gather moisture as they cross the Pacific Ocean. When they hit the uplift of the High Sierra range in the afternoon heat of a summer day, clouds are formed that then dissipate with rain or the cooling in the evening. This natural phenomenon has been going on for millions of years.

And yet, something beyond the raw data is captured in this photo. *Homo sapiens*, the same species that is capable of comprehensive destruction, have also developed the brain capacity to create meaning in the form of art. This dichotomy both sets us apart from other creatures and makes the times we live in so fascinating and confounding.

When I first started in photography, I thought Ansel Adams was the embodiment of what a photographer and a productive citizen could and should be. His inspiration came from the mountains, and that enthusiasm can now be passed down through his photographs for generations to come.

David Brower, director of the Sierra Club in the turbulent 1960s, wrote a book late in his life called *Let the Mountains Talk, Let the Rivers Run: A Call to Those Who Would Save the Earth*. Adams, who had a very public falling out with Brower, though they reconciled before Adams' death, knew how to make the mountains talk through the language of photography. I vote for reconciliation and a return to nature as a source of beauty and renewal.

Let the mountains talk, let the rivers run, let the lakes shine, let the clouds rise.

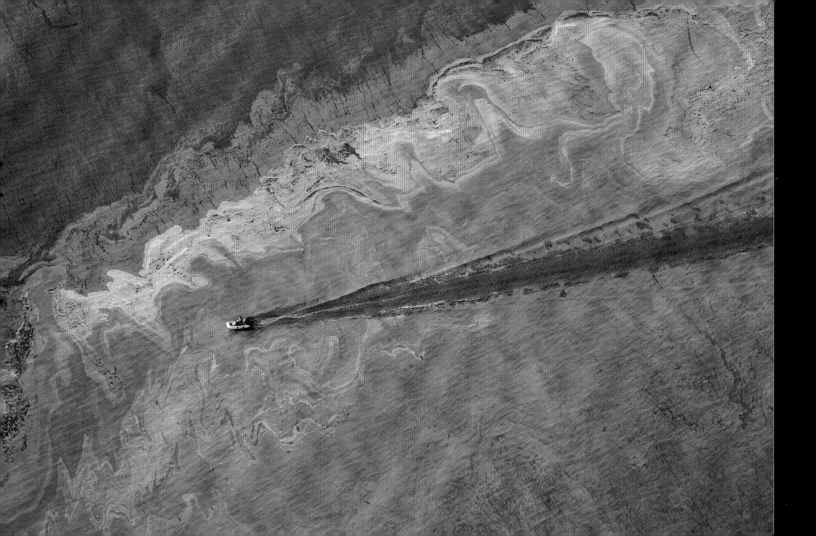

Lake Erie: A Not-So-Natural Summer Green

There are many species of single-celled organisms living in the Great Lakes, including algae. In certain conditions, these organisms can reproduce rapidly. This dense population of algae is called a bloom. Some blooms are harmless, but when the organisms contain toxins, noxious chemicals, or pathogens, it is known as a harmful algal bloom, or HAB. They can cause harmful conditions to aquatic life as well as humans.

In the summer of 2011, I started to watch the "Harmful Algal Blooms in Lake Erie" bulletins that were released weekly by the Great Lakes Environmental Research Laboratory. The email bulletins showed data from satellite images that told whether a bloom, usually of cyanobacteria, had been detected in Lake Erie. It also gave a forecast, based on wind and temperature conditions, of the likelihood that the bloom would spread.

In mid-July, a bloom was detected near Toledo, Ohio. Wind and high temperatures usually spread a bloom before it dies out in the fall. The algal blooms are caused by nitrogen runoff from fertilizer on lawns and farms. Since Lake Erie is situated in the American Corn Belt, the big culprit is agriculture. By September 1, when this photo was taken, the bloom had spread over most of Lake Erie. Results of the bloom included closed beaches and health advisories warning people not to touch the water or eat fish from the lake.

I was working on a story about nitrogen fertilizer runoff, and I hired a plane in Toledo so I could take aerial photos of the bloom on Lake Erie. It was a much greater scale than I had imagined. To my surprise there were still a lot of people in boats on the lake. Either they were oblivious to the toxic water they were sailing upon, or perhaps the bloom was not as apparent from the ground as it was from the air. Or maybe the boaters were just used to green water in the late summer.

Harmful algal blooms are now present in 375 estuaries around the world. Excessive nitrogen in the water is the fuel that feeds them. Sometimes the source is nitrogen from the tail-pipes of vehicles that is deposited on roadways and eventually washed into waterways. Sometimes the nitrogen comes from excess fertilizer placed on lawns, golf courses, and farms. The algae that form have a voracious appetite for the nitrogen, and they eventually suck all the oxygen out of the water. In the deeper waters of some estuaries, this causes dead zones where nothing can live due to the anoxic conditions.

Usually, the algae are not toxic, but there is a toxic amino acid produced by cyanobacteria called beta-methylamino-L-alanine, or BMAA. This neurotoxin is considered a possible cause of amyotrophic lateral sclerosis (ALS), also known as Lou Gehrig's disease. A few years ago, Elijah Stommel, a neurologist at the Dartmouth-Hitchcock medical center in New Hampshire who works with ALS patients, discovered the connection between environmental factors and this degenerative disease. A high number of his patients lived around Mascoma Lake in Enfield, N.H.—a lake that frequently had algal blooms in the past decade. He has since documented a significant statistical increase in the incidence of ALS cases near bodies of water with a history of toxic algal blooms.

BMAA bio-accumulates in the food chain and is found in high levels in seafood. It turns out that shark fins have an extremely high BMAA level, which—along with saving sharks—is a good reason to avoid shark fin soup. Those unnatural blooms of green algae in the summer are proving harmful to our estuaries, the aquatic life that lives in them, and to us as well.

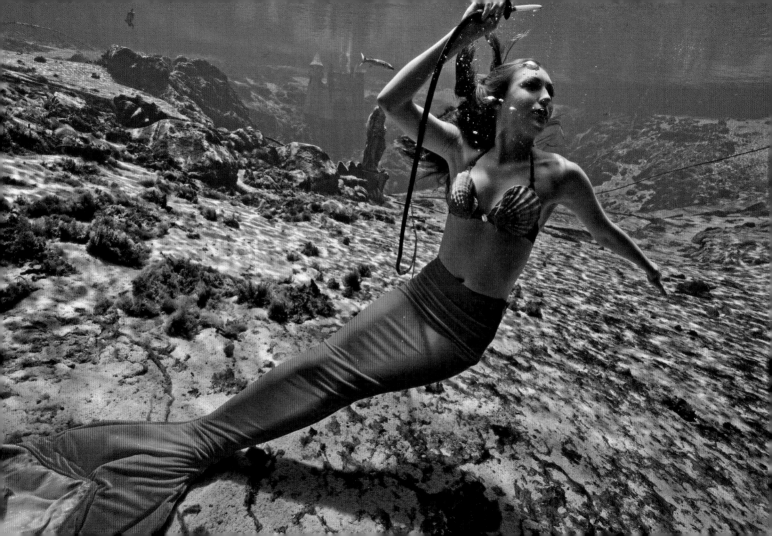

The Mermaid Show: Florida Before the Sprawl

Weeki Wachee is the name of a city in northern Florida most notable for the Weeki Wachee Springs and the world-famous mermaid show. It is hard not to smile while saying the name Weeki Wachee. As it turns out, the place is a lot of fun, too.

The Seminole Indians named the springs. Weeki Wachee means *little spring* or *winding river*. Each day the springs discharge 112 million gallons of freshwater through a limestone vent into a large pool. The current flowing out of the spring is so strong that it has been hard for divers to explore the cave system where the spring originates. However, during a drought in 2007, cave divers were able to map 6,700 feet of underground passages to a depth of over 400 feet, making Weeki Wachee the deepest underground spring in the U.S., although the bottom has yet to be reached.

Newton Perry, a former Navy SEALs trainer, started the mermaid show in 1947. According to the Weeki Wachee web site, "Newt scouted out pretty girls and trained them to swim with air hoses and smile at the same time. He taught them to drink Grapette, a non-carbonated beverage, eat bananas underwater and do aquatic ballets." He put out a sign on U.S. Route 19 advertising the show. This was during a time when there weren't too many cars, so when a car did drive by, the women all ran out in their bathing suits and tried to lure the driver into the 18-seat theater that was carved into the limestone six feet down and with windows so the audience could look right into the spring.

The 1960s were the heydays of the show when 35 mermaids were employed and the theater was expanded to seat 400 people. I photographed a slimmed-down show in 2012 for a story about the effects of nitrogen fertilizer. There are historical photos from 1947 that show native eelgrass growing on the spring bottom. The eelgrass has now been replaced by the algae, which can be seen in the background of my photograph.

Algae grow because the spring now has ten times the level of nitrogen in the water than it did before development. The town of Weeki Wachee only has 12 residents, but there has been explosive growth in the watershed that feeds the spring. The nitrogen comes from fertilizer runoff from the green lawns of residences nearby.

To photograph the mermaids, I first tried to shoot through the window, but the quality of the exposures was not very good. Next, I put on scuba gear, and between shows I tried photographing the mermaids from inside the pool while they posed for my underwater camera, but I wasn't satisfied with the results. Finally, I got permission to photograph the mermaids during the show providing I stayed in a position just below the viewing window. The visitors could see my bubbles, but that was the only way to get an honest photo of the mermaids at work. That method turned out to be the best way to get the photograph.

I have to admit that I had a good time photographing the mermaids. I came away with a healthy respect for the job they do. It takes about a year of training for the mermaids to learn to keep their buoyancy during the show by filling up their lungs with air and slowly releasing it. I'm glad that this historic roadside attraction remains, but it would be even better if the springs could be restored to their former glory.

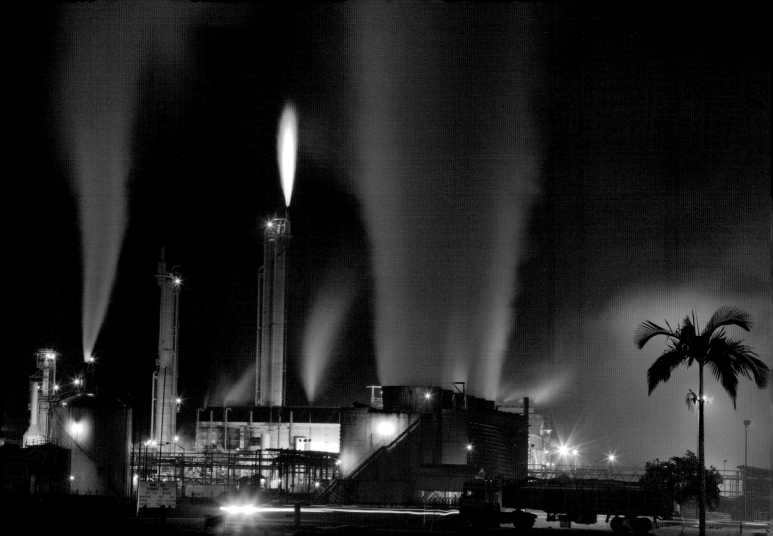

Fertilizer: Can't Live Without It or With It

About a hundred years ago, two German scientists, Fritz Haber and Carl Bosch, discovered how to make synthetic nitrogen from the atmosphere. The process involves heating nitrogen under pressure over a hydrogen catalyst to make ammonia. This takes tremendous amounts of energy, and during the production, carbon dioxide is released as a by-product, warming the atmosphere. Despite these negatives, this invention is how fertilizers are produced, thereby making modern, large-scale agriculture possible. It is estimated that without synthetic nitrogen, it would be impossible to feed about 40 percent of the people alive today.

Most fertilizer plants use natural gas as their energy source. In the last 20 years, no new fertilizer plants had been built in the US, but 14 are currently being proposed. This is most likely in response to the new abundance of natural gas in the US and the growing demand for fertilizer worldwide.

The production of ammonia-based fertilizer is not without risk. On April 17, 2013, an explosion occurred at a fertilizer plant in West, Texas; fifteen people died and more than 160 were injured. The initial cause of the fire is unknown, but investigators determined that ammonium nitrate was the trigger for the explosion,

This fertilizer plant in Nigeria is unique. In 2013 it was the only one in Sub-Saharan Africa. To get to this plant I flew from Lagos to Port Harcourt, Nigeria. I was met at the airport by three heavily armed security guards and two vehicles that were waiting to escort me to the fertilizer plant. The trip took several hours, and all the while I was locked in the second vehicle with a siren continually blaring. The plant was inside a well-protected compound. This high level of security is required when a white person visits because of the possibility of kidnapping by groups fighting against the oil interests in the region.

The plant stands at the center of the debate about how Africa should develop agriculturally. The Nigerians who run the plant strongly believe that their country has the resources to help the rest of Africa. The plant is powered by natural gas, which is found in abundance in the Niger Delta. Most of the natural gas that is recovered with the oil in the delta is currently just flared off because Nigeria doesn't have the pipelines to transport it. It has been calculated that if Nigeria could make fertilizer with all this natural gas that is now being wasted, they could theoretically feed all of Africa. No more famines, no more need for foreign aid: just Africans feeding Africans. However, with the benefits come the problems of pollution, too.

So when I look at this photo, part of me wishes that Africa would stay away from industrialized agriculture and develop along the lines of permaculture, native nitrogen-fixing plants, community gardens, and the like. But if I am honest, I also admit that as a resident of an industrialized country I am enjoying the benefits of synthetic nitrogen, which allows me to live in a large city where I can go into a supermarket filled with fresh food. So who can fault our brothers and sisters in Africa for wanting to live the good life, too? Ultimately, as citizens of the world, we all will have to find a more just, natural, and sustainable way of life in order for everyone to fulfill their dreams.

Afterword: Environmental Wisdom and the Courage to Face the Future

For many, the environmental pictures throughout this book may be depressing. It is much easier and more pleasant to turn away and not subject our sensibilities to this unwanted noise. Perhaps an environmental journalist who takes such pictures just has a taste for the dystopian. As one who has spent a good part of my creative life making these types of photos, I have, at times, pondered my motivations for doing the work that I do.

In recent years I have come to a more positive view, not just about my own work, but about all the activists, scientists, artists, and ordinary citizens who are drawn to such subject matter. To those who research, write about, make art, or protest in defense of the workings of nature and the environment, I can only applaud their willingness to face the future with clear eyes and a strong heart.

It could be that we evolved to care only about our next meal or our next night's lodging, but today we can understand what our future holds in ways that were unthinkable just a few decades ago. The science is telling all of us that we need to turn off our selfish genes and work together for the good of humanity and for the diversity of all the life that surrounds us. That decision takes courage, which at times has been in short supply; but the strength I have witnessed in others working on behalf of the planet gives me hope that we can build a better world.

Peter Essick
October 2013

Acknowledgements

This book covers the major portion of my career in photography, and I am thankful for the family, friends, and colleagues who have helped me along the way. To my father, John, who instilled in me a love of science and the outdoors, and who first introduced me to photography; and to my mother, Rose, who went along on all the trips and is always thinking positively. I am most grateful for their love and support.

To my teachers: Leon Frankamp, my high school photography instructor at Burbank High School; Glen Allison, an architectural photographer who I worked for as an assistant in southern California; and Bill Kuykendall, David Rees, and Mike Zerby, instructors at the University of Missouri School of Photojournalism. I learned much about the craft and joys of photography from each of them at a stage in my life when everything about photography seemed new and exhilarating.

At *National Geographic* there are many to thank. Thanks to Rich Clarkson, who gave me a summer internship, my foot in the door at *Geographic,* and introduced me to the world of photojournalism; to former Editor Bill Allen and current Editor Chris Johns, both whom have guided the magazine through some difficult times for print media while always maintaining excellent standards. Most of my work in this book was done while they were editors and I thank them both for supporting my work. Thanks to Environmental Editor Dennis Dimick who was either the picture editor or advisor for most of the environmental stories mentioned in this book and whom I appreciate for his support and his ongoing efforts to champion important environmental stories. Thanks to Senior Editor Susan Welchman, the picture editor on many of the stories in this book. I always appreciate her excellent editing and feedback in the field. There are many others I have worked with at *Geographic* including Victoria Pope, Terry Adamson, Tom Kennedy, Kent Kobersteen, Bill Marr, David Whitmore, Elaine Bradley, Glenn Oeland, Bill Douthitt, Sarah Leen, Ken Geiger, Kurt Mutchler, Sadie Quarrier, Elizabeth Krist, Todd James, Kim Hubbard, and Pamela Chen.

There have been guides in many countries that have helped me with language translation and navigating cultural differences: Olli Lamminsalo in Finland, Peter Meyer in Australia, Poul Erik in Greenland, Kunio Kadawaki in Japan, Jesus Lopez in Mexico, and many more who I have regrettably lost track of through the years.

At The Paideia School, where my son is in the eight grade, there is a wonderful community of people, many who support the arts, including Paul Bianchi, Barbara Dunbar, Judy Schwarz, Liz DeSimone, Kim Dennis, Zan McBride-Spence, Jay and Laura Sadd, Todd and Amy Zeldin, Howard and Jiffy Page, Melissa Walker, Julia and Kenneth Neighbors, Lisa Baeszler, Pat Fox, Martha and Sean Cook, Tracy and Joe Delgado, David and Kirsti Perryman, Bill Levisay, Jennie Saliers, Jennifer and Scott Manning, Patrick and Lisa Whelchel, Christine Coussins, Kelly and Peter Richards, Dr. Otis Brawley and Yolanda Ross, Marion and Christopher Kunney, Mary Lynn and Joseph Cullen, Patti Willard, Beth and Dean Athanassiades, Phil and Allison Wise, Debbie Austin, James and Priscilla Hefflefinger, Brian and Jessica Eames, John and Margaret Willingham, Patti Sullivan, Ernest Gubry, Scott and Sarah Ellyson, Dianne Bush, and Ben and Kathy Barkley.

Many friends have supported me and my work including Virginia Lane, Debbie and Mike Wilson, Gail Orendorff, Michon Washington, Sue McDonald, Bonnie Baskin, Tom Bennett, Stephen Wilson, Christopher Hugnin, Troy Butler, Bruce and

Marty Aron, Angela Freeman, Edward Melisky, Amy Hanson, Dean McMath, James and Liesa Johnson, Derek and Lori Stotts, Eddie Thomas, Linda Berkowitz, Scott Seritt, Jane Reeves, Judy Bice, Brian Creasy, Allan Nagy, KeKe Rice, Lisa Favors, Patti Sullivan, Shan Franklin, Steve and Elaine Brill, Jim Castleberry, Carolyn Blum, Frank Boyd, Joe and Vivian Birts, Wallace Bryan, DeJuan Baker, Vonda Dickerson, Heather Eason, Michael and Lisa Schtroff, Sarah Hall, Carolyn Glover, Sid and Tahira Catlett, Suzie and Jack Kleymeyer, Lynn Keifer, Tom and Kristi Nissalke, Kathy McDonald, Bonnie Baskin, Tom Bennett, Sarah Hall, Carolyn Glover, Sid and Tahira Catlett, Suzie and Jack Kleymeyer, Lynn Keifer, Tom and Kristi Nissalke, Kathy Miller, Felicia and Victor Walls, Jesse and Vonda Perkins, Rick and Hilda Alberts, Bernard Wright, Kohl Sudnikovich, Bernard Taylor, Lerita and Columbus Brown, Kate Yeager and Hillard Weinstock, Jim and Gina Wakeman, Mary Jo Bryan, Dr. and Mrs. Raymond Rosenberg, Katrina Williams, Keith Kinsler, Dr. Brian Levitt, Dr. David Jacobson, Richard and Judy Carter, Joe and Lynn Amaya, Mark Perryman, Kyle Campbell, Sarah Fink, Sarah and Brad Klink, Anne and Darren Sorrenson, Mary Harris, John and Ellen Heath, Andrew Kornylak, Ramon Pooser, Sona Chambers, Debbie McMinn, Larry and Connie LaVine, Lou Zamperini, Loup Langdon, Kathryn Kolb, France Dorman, Bill Nix, Randy Hyman, Jose Azel and the rest of the team at Aurora Photos, Robert Yellowlees and Tony Casadonte at Lumière, Gabrielle Larew at DoMA, and *Illumination* magazine for the inspiration of the title.

Many thanks to Gerhard Rossbach for publishing this book in such a fine and thoughtful manner, and to Joanie Dixon, Maggie Yates, Allie Smith, and Petra Strauch at Rocky Nook. In what turned out to be a fortunate twist of fate, I photographed Joanie and David Dixon's wedding many years ago.

Most of all I would like to thank my wife, Jackie, and son, Jalen, who have the difficult job of living with a peripatetic photographer. I love you both very much.

Technical Information

Like every photojournalist of my era, my work can be divided into film and digital capture. I switched to digital in 2006, and because of the magic of IPTC data, I have much more accurate technical information of my more recent work. I didn't record the exposure data for my pictures on film, so the best I can do is give an informed guess on the settings.

My technical approach is relatively simple and straightforward. I usually carry just one Canon DSLR and three lenses. Currently, they are the Canon 16–35mm, 24–105mm, and 70–200mm, which all fit into a small daypack. I use a Gitzo carbon fiber tripod and an Arcatech ball head. I prefer to travel light and add special equipment only when needed.

Cover: Icebergs, Eqaluit Ilua, Greenland. 2010
Canon 1Ds Mark III, 70–200mm lens, ISO 200, 1/30 sec at f/16

This photo was taken at the same location as the photo of the Inuit potato farmers (page 90). I got up early before the harvesting began and saw several icebergs that had moved in close to shore during the night.

Page ii Sea ice, Seno Pia, East Arm, Tierra del Fuego, Chile, 2009
Canon 1Ds Mark III, 24–70mm lens, ISO 160, 0.7 sec at f/22

This sea ice was left behind on the grassy bank when the tide went out. I didn't have a macro lens with me, so I used an extension tube to get closer in on the ice formations. These formations came and went two times a day, but the frost was most apparent in the morning.

2 Kitka River, Oulanka National Park, Finland, 2009
Canon 5D, 24mm TS lens, ISO 500, 30 seconds at f/11

The circular forms were rendered in the time exposure by the movement of small icebergs caught in an eddy of the river. I waited until dusk so I could take a 30 second exposure to get the pattern. It might also be possible to use a neutral density filter to achieve a long exposure, but I have found that the mood is not the same with that approach. I composed to minimize the area of white sky and to place the one tree in the center of the circle.

4 Kula canoe and shells, Trobriand Islands, Papua, New Guinea, 1992
Nikon, 24mm lens, Kodachrome 64, 1/125 second at f/11

During this period I worked with a Nikon F4 and 24mm, 35mm, and 85mm lenses. The lighting is pretty harsh at midday, but the water looks very blue at this time. The trading of kula shells is an important part of the Trobriand culture, but only happened once during the eight weeks I was on the islands. I was photographing the men preparing the boat when the woman came with the shells in the basket on her head. I had no advance notice, so I had to arrange the elements very quickly so that the basket was against the sky and she was not overlapping the boat.

6 Amish cornhusker Robert Slabaugh, on his farm near LaGrange, Indiana, 1993
Nikon F4, 24mm lens, Kodachrome 64, 1/125 second at f/8

I was standing in a horse-drawn cart full of corn, looking down at the Amish man working. The Amish don't want to be photographed in a way that they are recognizable, so I had to make sure he was looking away and his wide-brimmed hat shielded his face. I also photographed in the late afternoon when the sun gave a golden color to the corn and the stalks.

8 Mirage volcano fountain, Las Vegas, Nevada, 1993

Nikon F4, 80–200mm lens, Kodachrome 64, 1/2 second at f/11,

I stood across the street and shot at dusk when the red lights on the water show up the best and there is still some ambient light on the people. The light streak in the foreground is from a car passing by.

10 Glen Canyon Dam, Arizona, 1993

Nikon F4, 80–200mm lens, Kodachrome 64, 1/125 second at f/11

Taken from a bridge above the dam, I used a telephoto lens to isolate the man against the concrete of the dam.

12 Kenroku-en Gardens, Kanazawa, Japan, 1994

Nikon F4, 50mm lens, Fujichrome 100, 1/125 second at f4

It was snowing heavily and although it was darker than on a bright sunny day, I always prefer to photograph in conditions like this that give a strong mood to the photograph.

14 Polluted sinkhole, near Bowling Green, Kentucky, 1996

Nikon F4, 80–200mm lens, Fujichrome 100, 1/250 second at f/5.6

Aerial photo was taken from a small Cessna plane with the window open. It is usually possible to take out a screw on the hinge to allow the window to swing open all the way. When flying, the slipstream will keep the window raised.

16 Golden Trout Wilderness, California, 1996

Nikon F3 with underwater housing and split diopter, 18mm lens, Fujichrome 100, 1/60 second at f/11.

A homemade diopter was used on the bottom half of the image to make it possible for everything to be in focus. There were a lot of trout in these waters and they would swim close by if I remained still.

18 Joshua Tree National Park, California, 1996

Nikon with 20–35mm lens, Fujichrome 100, 1/15 second at f/11

Sunset lighting on the rocks looked the best just as the light was starting to move off the foreground but was still vibrant on the background.

20 Smog-stressed trees, San Bernardino National Forest, California, 1997

Canon 1V, 70–200mm lens, Fujichrome 100, 4 seconds at f/11

This is a typical dusk-dark photo of a city, but with the unusual shapes of the trees in the foreground. I had to climb around quite a bit to find an angle where the trees were silhouetted against the lights of the city.

22 Glen Canyon Dam, Arizona, 1997

Canon 1V with 14mm lens, Fujichrome 100, 1/125 second at f/16

Taken at midday when the water from all four of the floodgates was in full sunlight. I had a very small area on which to stand above the man, and just a slight movement with the 14mm lens made a big difference in the composition.

24 Deer Creek, Arizona, 1997

Canon 1V 20–35mm lens, Fujichrome 100, 2 seconds at f/11

The hardest part of this photo was just getting down into the canyon from above. Once down by the creek, I looked for a place where the sunlight was bouncing off the sandstone and reflecting golden light on the opposite wall.

26 Altamaha River, Georgia, 1998

Canon 1V, 70–200mm lens, Fujichrome 100, 1/2 second at f/16

When the air temperature is colder than the water, mist forms on the river. As the warmer water evaporates, it cools rapidly and small water droplets are formed. The greater the difference in temperature, the more mist there will be.

28 Kalmiopsis Wilderness, 1998

Canon 1V, 70–200mm lens, Fujichrome 50, 2 seconds at f/16

Taken at dusk from across the rather large river with a telephoto to compress the river and the tree on the opposite bank.

30 Tracy Arm Wilderness, Alaska, 1998

Nikon F4, 24mm lens, Fujichrome 100

Photographed from a small zodiac boat with my spare equipment that hadn't been ruined two days earlier when the floatplane I had been in sunk with almost all of my equipment.

32 Houghton Crater, Devon Island, Canada, 1999

Canon 1V, 70–200mm lens, Fujichrome 100, 1/60 second at f/16

During the summer in the far north there is no sunset light. This was the only time in the whole month I was there when the lighting was interesting—just after an afternoon thunderstorm.

34 Superfund site, Leadville, Colorado, 2000

Canon 1V, 20–35mm lens, Fujichrome 100, 1/60 second at f/11

Midday light helped bring out the colors of the polluted water.

36 Young boy in window, Butte, Montana, 2000

Canon 1V, 70–200mm lens, Fujichrome 100, 1/125 second at f/8

This was a grab shot where I was just able to get a few frames before the boy moved out of the window. The soft, afternoon light helped to balance the contrast.

38 Isle of Pines, New Caledonia, 2000

Nikon F3 with underwater housing and split diopter, 18mm lens, Fujichrome 100, 1/60 second at f/11.

Photo was taken in midday sun in order to light up the water.

40 Pine Falls Log Yard, Winnipeg, Canada, 2002

Canon 1V, 70–200mm lens, Fujichrome 100, 1/250 second at f/5.6

Late afternoon light was used to bring out the texture on the logs. This is an aerial photo taken from a small Cessna airplane with the window open.

42 Three Mile Island Nuclear Plant, Pennsylvania, 2002

Canon 1V, 16–35mm lens

Shot from a spot on the opposite shore next to a beacon for boat traffic where I set up for a dusk photo. I anticipated the glow of the lights on the cooling towers and the steam coming from the still operational towers, but it wasn't until I saw the film that I realized the green cast of the beacon was so apparent.

44 High level waste, Infinity Room, Idaho Nuclear Engineering and Environmental Laboratory, 2002

Canon 1V, 16–35mm lens, Fujichrome 100, 1/4 second at f/11

Photo taken through a very thick glass-viewing window. I put the camera on a tripod, moved the lens as close as possible to the glass, and used some black felt to block out reflections of lights behind me. The green cast came as a result of the color temperature of the sodium vapor lights on daylight film.

46 Young girl bathing, Calcutta, India, 2002

Canon 1V, 16–35mm lens, Fujichrome 100, 1/125 second at f/11

I was riding in a car as it was driven through the city when I saw this girl bathing in front of her house. In this part of India people are used to bathing and washing out in the open because the tube wells are next to the road. I had the driver stop, jumped out of the car, and started shooting. In some parts of the world, this might not be welcome, but here the mother and daughter didn't mind being photographed.

48 Tofu plant pollution, Yellow River, China, 2002

Canon 1V, 16–35mm lens, Fujichrome 100, 1 second at f/11

> When the afternoon sun was hitting on the water, the scene was too contrasty. I waited until dusk to capture the pink colors in a softer light.

50 Torres Del Paine National Park, Chile, 2004

Canon 1V, 24mm TS lens, Fujichrome 100, 1/8 second at f/11

> I used a two-stop neutral density filter on the sky. This amazing light lasted for only a couple of minutes at sunrise. The rest of the day was cloudy and overcast.

52 Sanibel Island, Florida, 2004

Nikon F3 with underwater housing, 18mm lens, Fujichrome 100, 1/250 second at f/11

> I had to get very close to the small wave in order for it to fill the frame, hence the need for an underwater housing to protect the camera from the salt water. I had to wash off the dome after each picture, and made many attempts because each wave was different.

54 Slash and burn farming, near Manaus, Brazil, 2004

Canon 1V, 16–35mm lens, Fujichrome 100, 1 second at f/11

> Photographed at dusk so some of the embers of the burned trees would register.

56 Coal-fired power Plant, Conesville, Ohio, 2004

Canon 1V, 24–70mm lens, Fujichrome 100, 1/15 second at f/11

> The sun was rising to the right and I used a 2-stop and a 3-stop neutral density filter to reduce the intensity of the light on the sky and smoke.

58 Fleismann's Glass Frog, Frog Pond, Monteverde, Costa Rica, 2004

Canon 1V, 180mm macro lens, Fujichrome 100, 1/125 at f/16

> I used a Canon Speedlight mounted on a bracket over the macro lens, set at minus 1/2 stop exposure.

60 Bleached coral, Maldives, 2004

Nikon F3 with underwater housing, 18mm lens, Fujichrome 100, 1/60 second at f/8

> Taken with available light at a depth of 20–30 feet. There was a lot of current there so it was difficult to remain still while taking the photograph.

62 Adélie Penguins, near Palmer Station, Antarctica, 2004

Canon 1V, 16–35mm lens, Fujichrome 100, 1/60 second at f/11

> These penguins were quite easy to photograph up close; they were sitting on their nests and wouldn't move if I stayed at a respectful distance. It was important to show the snow around the nests of the penguins. The warmer weather has caused more snow in this part of Antarctica, and research has shown that the penguins' numbers are decreasing here because the Adélies don't like snow on their nests.

64 Lonnie Thompson, ice core storage, Ohio State University, Ohio, 2004

Canon 1V, 16–35mm lens, Fujichrome 100, 1/15 second at f/11

> I used a combination of Lumedyne 200 watt portable strobes and Dedolight tungsten lights to take this photograph in a minus 20 degrees F freezer. I put blue gels on the two tungsten lights in the background and a soft box on the strobe light to create a softer light on the subject.

66 Boaters on the banks of the Patuxent River, near Benedict, Maryland, 2005

Canon 1V, 16–35mm lens, Fujichrome 100, 1/125 second at f/11

This situation appeared and disappeared quickly. I used a wide-angle lens from a low angle to isolate the people in the background against the sky.

68 Home Depot parking lot, Baltimore, Maryland, 2005

Canon 1V, 16–35mm lens, Fujichrome 100, 8 seconds at f/16

I took several eight-second exposures during the storm with the hope that one would register a lightning bolt. A lightning trigger would be a better way to do such a photo.

70 Environmental Test Chamber, Georgia Tech Research Institute, Atlanta, Georgia, 2006

Canon 1D Mark II 16–35mm lens, ISO 400, 1.5 seconds at f/6.7

I used four Dedolight tungsten lights for the lighting in this photo. A Dedolight with a blue gel was placed behind the desk, one was focused on the desk, and two were bounced off the ceiling. The stainless steel walls and ceiling are used because they are inert and don't contribute chemical emissions of their own. I had to be careful with the placement of the lights because of the multiple reflections off the stainless steel, but the reflections also made the photo more visually interesting.

72 Pesticide sprayers near Jalapa, Nicaragua, 2006

Canon 1D Mark II, 16–35mm lens, ISO 320, 1/180 second at f/13

The netting overhead gave a soft light to the scene, and taking this photograph was pretty routine. The biggest decision I had to make was how close to get to the pesticide spray as the workers moved past me.

74 Tran Huynh Phuong Sinh, age 4 with Fraser Syndrome, at Peace Village, Ho Chi Minh City, Vietnam, 2006

Canon 1D Mark II, 16–35mm lens, ISO 640, 1/90 second at f/5.6

There was indirect window light illuminating this scene. A woman was feeding breakfast to several of the children in the room who were all sitting on the floor. I had to stand overhead to look downward which created a graphic element of the floor design and eliminated the bright windows and other distracting elements from the photograph.

76 Boy with computer wires, Accra, Ghana, 2008

Canon 1D Mark II N, 16–35mm lens, ISO 250, 1/60 second at f/22

Taken under hazy sunlight, I only had time for a few frames. I used a small aperture to show the shantytown in the background, where the boy lived.

78 Plastics recycling facility, MBA Polymers, Kematen, Austria, 2008

Canon 1D Mark II N, 16–35mm lens, ISO 200, 30 seconds at f/13

I saw this pile of plastics outside the recycling facility where I was taking a tour. I arranged to come back at dusk and take the photograph illuminated by two security lights behind me.

80 Snowstorm, White Rock Mountain, Arkansas, 2008

Canon 1D Mark III, 70–200mm lens, ISO 400, 1/45 second at f/19

The misty light of a snowstorm is always a good way to photograph a forest. A medium telephoto was used to isolate a section of the forest and eliminate most of the bright sky from the scene.

82 Seno Pia, West Arm, Tierra del Fuego, Chile, 2009

Canon 1Ds Mark III, 24–70mm lens, ISO 500, 1/350 second at f/4

I photographed from the front of a slow-moving boat. The reflection of the water looked the best with this approach. When we stopped, the ripples took many minutes to settle, so I preferred to move slowly through the waters and use a fast shutter speed.

84 Suncor Oil Sands Mine, near Fort McMurray, Alberta, Canada, 2009

Canon 1Ds Mark III, 24–70mm lens, ISO 500, 1/180 second at f/4.5

Photographed from a small Cessna airplane with the window open. I was able to use a 1/180 second exposure—which is slower than normal—because the plane was moving away from the scene and I was looking back toward the tail, which created less relative movement.

86 Albian Sands Tailings Pond, near Fort McMurray, Canada, 2009

Canon 1D Mark III, 16–35mm lens, ISO 400, 1/180 second at f/9.5

Photographed from a boat at sunrise. I used a two-stop neutral density filter to darken the sky.

88 Moonlight, Oulanka National Park, Finland, 2009

Canon 5D, 24mm TS lens, ISO 1250, 30 seconds at f/4.5

The moon was rising on my right and created the side lighting on the trees. The stars appear as points in a 30 second exposure with a 24mm lens. The formula is 600/focal length of the lens to determine what exposure length is necessary to render the stars without movement.

90 Potato farmers, Eqaluit Ilua, Greenland, 2010

Canon 1D Mark III, 16–35mm lens, ISO 500, 1/180 second at f/9.5

I used a 2-stop neutral density filter to darken the sky. There was a soft afternoon light illuminating the three workers.

92 Wathumba Creek Estuary, Fraser Island, Australia, 2010

Canon 1Ds Mark III, 70–200mm lens, ISO 500 1/1500 second at f/5.6

Photos of clear water in the tropics usually look better in midday when the light penetrates deep into the water, creating vibrant colors.

94 Dingo, Tukkee Sandblow, Fraser Island, Australia, 2010

Canon 1D Mark III, 500mm lens, ISO 250, 1/2000 second at f/4

I handheld the 500mm lens while following the dingo a reasonable distance from the side. It is possible to handhold super telephotos if you use a very fast shutter speed.

96 Garnet Lake, Ansel Adams Wilderness, California, 2011

Canon 1Ds Mark III, 16–35mm lens, IOS 125, 1/125 second at f/11

It was raining a little when I took this photo with a 2-stop neutral density filter on the sky. I had to keep drying the filter as the light changed quickly as the sun went in and out of the clouds.

98 Algae bloom on Lake Erie, near Toledo, Ohio, 2013

Canon 1D Mark IV, 24–105mm lens, ISO 640, 1/500 second at f/5.6

This aerial photo was taken from a small Cessna airplane. It is always a challenge (but part of the fun) to try to line up two moving objects—in this case the boat and the plane.

100 Mermaid Show, Weeki Wachee Springs, Florida, 2013

Canon 5d Mark II with underwater housing, 17–40mm lens, ISO 800, 1/350 second at f/13

There was plenty of light underwater in the springs, but it was all coming from the top. Hence, the photo that worked best was when the mermaid looked up for just a few seconds.

102 Notore Fertilizer Plant, Port Harcourt, Nigeria, 2013

Canon 1Ds Mark III, 70–200mm lens, ISO 100, 30 seconds at f/11

The only time the orange glow appeared behind the tree was at night. This was actually a flare that could be seen in the photos at dusk and dawn.

Recently named by *Outdoor Photography* magazine as one of the 40 most influential nature photographers, Peter Essick has traveled extensively over the last two decades, photographing around the world. He is a working photojournalist, but his photographs move beyond mere documentation; they reveal the spiritual and emotional aspects of nature and the impact of development on the landscape.

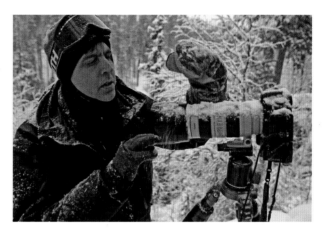

Essick has been a frequent contributor to *National Geographic* magazine for 25 years, where he has produced 40 feature articles on an array of topics. Some of his favorite and most rewarding stories have been on Inner Japan, the National Wilderness Preservation System, the carbon cycle, global warming, and global freshwater. Recent stories include a June 2010 cover piece on Greenland and a story on the Ansel Adams Wilderness in the October 2011 issue.

Essick has a bachelor's degree in business from the University of Southern California and a master's degree in photojournalism from the University of Missouri. He is represented by the Lumiere gallery in Atlanta and by Aurora Photos. He lives in Stone Mountain, Georgia with his wife, Jackie and son, Jalen.